My Kind of County

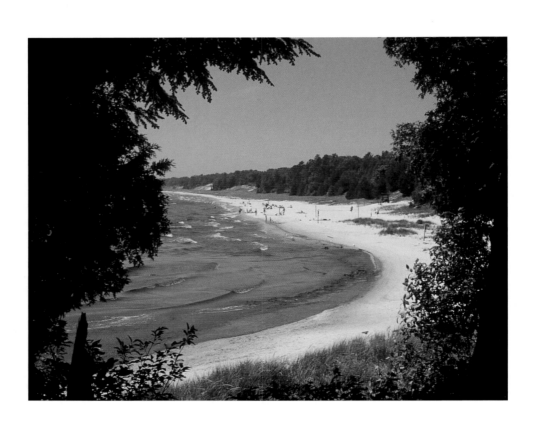

My Kind of County

Door County, Wisconsin

JOHN FRASER HART

The Center for American Places
at Columbia College Chicago

in association with
The Elizabeth Firestone Graham Foundation

The Center for American Places at Columbia College Chicago
600 South Michigan Avenue
Chicago, Illinois 60605-1996, U.S.A.
www.americanplaces.org

Distributed by the University of Chicago Press
www.press.uchicago.edu

16 15 14 13 12 11 10 09 08 1 2 3 4 5

Library of Congress Cataloging-in-Publication Data

Hart, John Fraser.
 My kind of county : Door County, Wisconsin / by John Fraser Hart. -- 1st ed.
 p. cm. -- (My kind of...)
 Includes bibliographical references and index.
 ISBN 978-1-930066-86-1
 1. Door County (Wis.)--Description and travel. 2. Door County (Wis.)--
Geography. 3. Door County (Wis.)--History, Local. I. Title. II. Series.

 F587.D7H37 2008
 977.5'63043--dc22

 2008040414

ISBN-10: 10-1-930066-86-4
ISBN-13: 978-1-930066-86-1

Frontispiece: Beach at Whitefish Bay on Lake Michigan. All photographs are by the author,
except as otherwise noted.

To the memory of Richard S. Davis
and to his daughter, Meredith,
without whom I could never have become
acquainted with Door County.

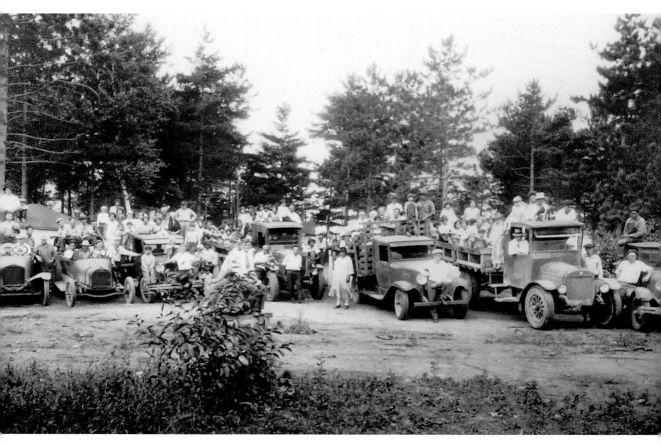

CHERRY PICKERS READY TO LEAVE FOR THE ORCHARDS IN THE 1930s, WHEN THE ENTIRE COUNTY TURNED OUT TO PICK THE FRUIT. PHOTOGRAPH COURTESY OF THE DOOR COUNTY HISTORICAL SOCIETY AND USED BY PERMISSION.

CONTENTS

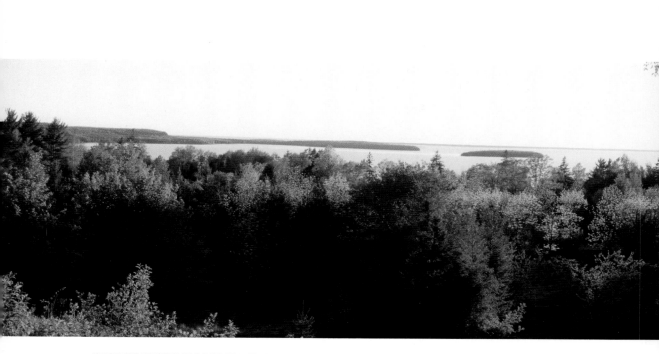

PANORAMIC VIEW OF EAGLE HARBOR IN EPHRAIM.

In 1915, David H. Stevens, an assistant professor of English at the University of Chicago, married Ruth Davis and took her to Door County, Wisconsin, for their honeymoon. They liked the county so much that they returned in 1917 and bought an old fisherman's shack on the shore north of Ephraim, which remained their summer home and became their permanent home when they retired.

In 1937, they talked Ruth's brother, Richard S. Davis, the star reporter for the *Milwaukee Journal*, into buying a three-acre lot on the crest of the escarpment overlooking their property. For years he did nothing with the property but pay taxes on it, but after his wife died in a tragic accident in 1952 he decided to build a summer home on the crest of the hill for his grandchildren, who are also my children, because I am married to his daughter, Meredith.

That fall his son, Dick, attended an auction when the old abandoned North Bay one-room schoolhouse was put up for sale. He bid $382, which was the total amount he had in his checkbook. He lost to a higher bidder, who turned out to be insolvent, so the schoolhouse became ours. We put it on rollers and moved it nine miles across the peninsula to our property. When we began to remodel it we discovered that it was actually a log structure that had been clapboarded over, so we have the original logs exposed on one wall of our living room; at a

later date we might have exposed all four log walls, but the one we have is good enough for us.

The house on the hill in Ephraim has been the constant in the life of my family as we have moved from Georgia to Indiana to Minnesota. Some years we have been there for the entire summer but other years not at all. For more than half a century, while I have aestivated in Door County, I have had great fun wandering the highways and byways of the peninsula, exploring its nooks and crannies, and observing the folk-ways of its inhabitants, both permanent and seasonal.

I have been fascinated by watching the peninsula change, and I have enjoyed sharing my discoveries with friends who have visited me, but I have never committed to paper what I have learned. When George F. Thompson, founder and director of the Center for American Places, invited me to write this book, he gave me an opportunity to be a teacher, because I believe the essence of teaching is sharing what I have enjoyed learning. Here you can read what I would tell you if we could wander around together in an area that I have come to love as my second home, even though I will always remain a "summer person."

The Chamber of Commerce claims that 2.1 million people visit Door County each year. Many, probably most, visitors think only of recreation when they think of the county, which is regrettable, because it has many fascinating facets, and tourism, despite its importance, is only one. This book explores some of those other facets that make the county an even more delightful place to visit and enjoy.

The mandatory first stop on the peninsula is the Door County Chamber of Commerce at 1015 Green Bay Road in Sturgeon Bay, on the east side of State Highways 42 and 57 about one mile south of the turnoff for downtown Sturgeon Bay. The visitor center is a veritable gold mine of information, with racks for more than 700 brochures that describe many of the lodging and eating places and other visitor-

related businesses in the county. Furthermore, each village has a brochure with a map of its business establishments.

Two essential publications both are free. The latest issue of *Key to the Door . . . Illustrated* lists all of the attractions in the county. This year's issue of *Menu Guide: A Guide to Door County Restaurants* has reproductions, complete with prices, of the current menus of most of the county's eating places. I could not have enjoyed and written about Door County without the aid of these and other published works that I have listed in the *Bibliography*, and to them and their authors I am deeply indebted.

I am even more deeply indebted to each of the wonderful people who have given me so generously of their precious time, answered my questions so patiently, and shared their wisdom and insights with me so graciously. This book owes much to Arnold R. Alanen, Al Blizel, Cliff Ehlers, John Enigl, Mark Ettinger, Robert Florence, Dennis Hickey, Hjalmar Holand, Tom Howard, Diane Kirkland, Bill Laatsch, Marvin Lotz, Pete Polich, Paul Regnier, Carol Rosen, Norb Schachtner, Dave Schartner, Ace Schmidt, Dennis Schopf, Bill Schuster, Dale Seaquist, George F. Thompson, and Dan Wagner.

I am grateful to Xuejin Ruan and Jonathan Schroeder, who drew the maps in the University of Minnesota Cartography Laboratory under the direction of Mark B. Lindberg, and to Jodi Larson, Heather Anderson, and Cat Holtman, who electronicized my typescript. I took all of the photographs that are not otherwise acknowledged.

My Kind of County

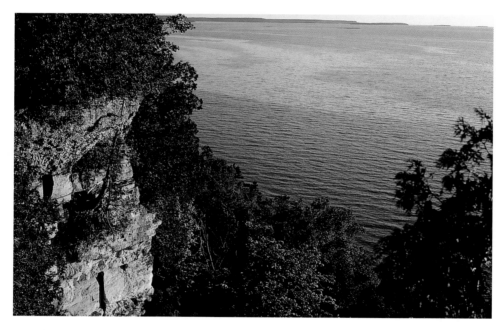

LIMESTONE BLUFFS ON THE GREEN BAY SIDE OF DOOR COUNTY.

The Door Peninsula is the long gnarled finger of northeastern Wisconsin that separates Green Bay from Lake Michigan. The geographic peninsula begins at the city of Green Bay, and Door County begins about halfway between the city and the town of Sturgeon Bay, but for many visitors "Door County" is synonymous with the peninsula north of Sturgeon Bay, because the northern half of the peninsula has most of its tourist attractions, and the lesser-known southern half remains more rustic (see Fig. 1 on page 129 in the *Gallery of Maps and Diagrams*).

The peninsula and the county take their name from the narrow strait between the northern tip of the peninsula and Washington Island, with Plum Island sitting "plum' in the middle." This strait is so treacherous that French fur traders called it the Porte des Mortes, or "door of the dead." Sailors dread it, because the currents are strong, the water is shallow, the shores are rocky, and the winds shift quickly and unpredictably. Local legend holds that the *Griffin*, the first sailboat ever to sail the Great Lakes and which disappeared mysteriously, was the first sailboat ever wrecked at Death's Door, which has been the scene of scores of shipwrecks and myriad near-disasters. It is a happy hunting ground for underwater archaeologists.

The Door peninsula is formed by the Niagara dolomite, a 500-foot thick layer of resistant, magnesium-rich limestone. This geological for-

3

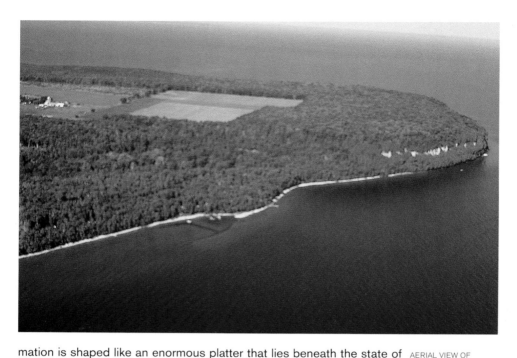

mation is shaped like an enormous platter that lies beneath the state of Michigan. The resistant edge of this formation is the Niagara Escarpment (cuesta), which loops around Lake Michigan and Lake Huron to form the Door peninsula, Manitoulin Island, and the Bruce peninsula in Canada, and then swings eastward to create the falls from which it takes its name (Fig. 2).

In Door County, the west-facing edge of the Niagara limestone forms bold bluffs that overlook Green Bay (Fig. 3). The formation shelves gently eastward beneath the waters of Lake Michigan with a slope of around forty-five feet to the mile. It was formed in a shallow tropical sea, and it contains many bioherms, which are fossil coral reefs that are singularly resistant to erosion. The rocks at Cave Point County Park have some especially nice examples of bioherms.

Glaciers helped to give the Door peninsula its contemporary shape. During the Ice Age an enormous lobe of ice more than a mile thick oozed inexorably southward from Canada through the Lake Michi-

gan basin. The long, narrow Door peninsula acted like a great razor that shaved off the western flank of the Lake Michigan lobe into a major sublobe that thrust southward through the lowland now occupied by Green Bay and Lake Winnebago. The debris that the ice deposited between these two lobes when they melted in southeastern Wisconsin is the picturesque Kettle Moraine.

Ice from the Green Bay lobe pushed up and over the limestone bluffs and across the peninsula. It scraped away the topsoil and even the less resistant bedrock, and it gouged out a set of subparallel lowlands that might have been preglacial stream valleys. The ice, which came from about twenty degrees west of north, notched a series of small bays on the west side of the peninsula that connect through poorly drained troughs to swampy lowlands and bays on the eastern side.

From north to south (see Fig. 1) these poorly drained subparallel lowlands extend: (a) through the Porte des Morts; (b) from Ellison Bay to Rowley Bay; (c) from Sister Bay to North Bay; (d) from Ephraim to Moonlight Bay and Baileys Harbor; (e) from Fish Creek to Kangaroo Lake; (f) from Egg Harbor to Clark Lake; (g) through the Sturgeon Bay embayment; (h) from Sand Bay to southeastern Door County; and (i) from Little Sturgeon Bay to Algoma, a lowland that is now drained by the Ahnapee River.

Most glacial ice probably was fairly dirty, because it contained all of the debris it had eroded from the areas across which it had passed. When the ice finally melted it deposited this debris, which is called till. Apparently the last glacier that covered Door County was cleaner than most, because it left only thin deposits. Most of the area north of Sturgeon Bay has no more than two to four feet of till over solid bedrock, and only the southwestern corner of the county has thicker deposits. The county has extensive outcrops of bedrock, and large areas of soils so thin and stony that they are hard to cultivate (Fig. 4).

The glacier came from the north, and even as the ice slowly melted back it formed a massive dam across the northern end of Lake Michigan,

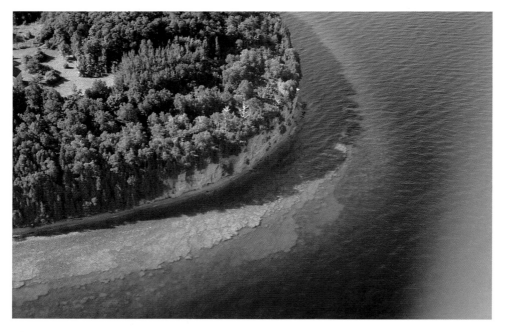

whose level stood as much as fifty feet higher than it is today. The level of

the lake dropped in stages as the ice melted or as its waters found new

outlets to the south. At each stage the waves in the lake carved steep

bluffs along the Green Bay shoreline in Door County, with gravel-covered

benches at their base. These ancient bluffs and benches are like giant

steps cut into the face of the modern cliffs, and geologists study them to

estimate the former levels of the lake.

Waves and currents in the lake on the gentle Lake Michigan side of

Door County have swirled sand southward along the shore to create

sand dunes onshore and sandbars beneath the water offshore. The

Ridges Nature Sanctuary north of Baileys Harbor has parallel belts of

sand dunes separated by poorly drained swales; these dunes are repli-

cated by parallel belts of sandbars under the shallow water at the head

of the bay.

The sand dunes at Whitefish Bay State Park have created Clark

Lake, which was once an embayment of Lake Michigan, and similar

dunes have created Kangaroo Lake, which was also once an embay-
ment. The level of Lake Michigan continues to fluctuate, albeit with a
narrow range; the average level is 578.6 feet above sea level, with a
high of 581 feet in 1986 and a low of 576 feet in 1964. A ten-foot drop
in the level of the lake would nearly turn Baileys Harbor into a new lake;
a ten-foot rise would nearly turn Clark Lake and Kangaroo Lake back
into bays of Lake Michigan, and it would turn the entire northern half of
Door County into an island by breaching the dune belt at the eastern
end of Sturgeon Bay.

The Niagara limestone of Door County has only limited economic
value, because the layers are thin, they split badly when cut or sawed,
and the rock becomes crumbly when it weathers; in many road cuts, it
does not look strong or solid enough to support anything. It does not
even make good stone walls. Many fields in Door County are stitched
together with long lines of light-colored stones, but these are merely
rocks that farmers have dragged from their fields and dumped in lines
of rubble that do not warrant the dignity of being called walls. Remov-
ing frost-heaved rocks from the fields is a constant struggle, and farm-
ers dump heaps of them in the middle of their fields where bare rock is
at the surface.

STONE WALL IN
A FIELD.

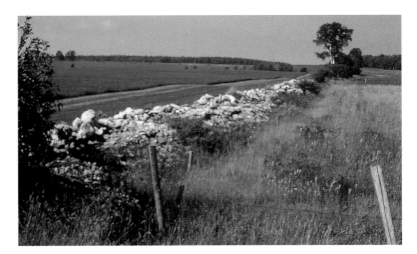

Nevertheless, the people of Door County have tried to use the stone, and the county is pocked with pits where they have excavated it for domestic use. They roasted it in kilns to make lime, which they used to tan leather and to make whitewash, cement, and glass. They crushed it to make road gravel, and back in the days before paved roads the county boasted that it had one of the finest highway systems in the state.

The principal use of Door County limestone, however, was to make riprap for harbor construction, and many ports around the Great Lakes still are protected by breakwaters of stone that was quarried in the county. As early as 1834 the federal government opened a quarry at Government Bluff, in what is now Potawatomi State Park, and during the heyday of the quarry business, between 1880 and 1920, the sides of Sturgeon Bay west of the city boasted no less than eight major quarries. They were close to water, so the stone could be shipped cheaply and easily to ports around the lakes.

Quarrying was hazardous work. Teams of two men drilled a row of holes in the top of the solid rock at an appropriate distance back from the edge of the quarry. One man held a steel chisel in the drill hole, the second kept pounding it with a heavy sledgehammer, and the first kept hoping that the second man was on target. When the holes were deep enough the men filled them with black powder and ignited it in an awesome blast that blew off the entire side of the quarry. Sometimes the charge held fire, only to blow up in the face of the man who went to find out why. In time, dynamite replaced black powder, but the work was still dangerous.

In the quarry, men loaded the stone onto carts drawn by horses, which eventually were replaced by steam engines, that pulled it on narrow-gauge railways on piers that ran far out into the bay to deep water, where it was loaded into the waiting barges that would haul it away. The largest and last of the quarries, which finally closed in 1944, is across the road from the Olde Stone Quarry County Park. The stone

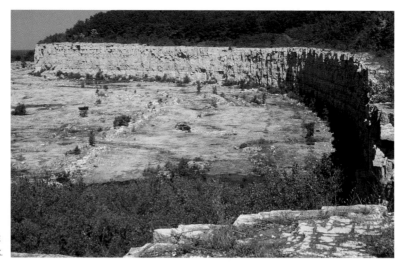

floor of this quarry has an area of more than a quarter of a square mile, and it is rimmed by sheer rock walls more than fifty feet high. It is one of the more spectacular sites on the peninsula.

Today, the most important characteristic of the limestone rock of Door County is its solubility, which is creating increasingly serious problems. Rainwater percolating down through the soil absorbs weak organic acids, and as it trickles through underground cracks and crevices in the rock it gradually dissolves and widens them. A splendid example of such solution is in the road cut on the west side of the crest of Plum Bottom hill, 2.5 miles north of Carlsville and 0.2 miles north of the junction of State Highway 42 and County Highway G.

Many parts of Door County are pockmarked with "rock holes," where the rock at the surface has been dissolved; these sinkholes carry surface water into a veritable maze of subterranean passages of all sizes. The county has some of the longest and deepest caves in Wisconsin. Horse-shoe Bay Cave is more than 1,800 feet long, with passages four to thirty feet wide, and Paradise Pit is more than 1,600 feet long. These caves are extremely dangerous even for experienced speleologists, and no amateur should be foolhardy enough to attempt to explore them.

One of the more distinctive types of natural features created by the ROCK HOLE IN A FIELD SOUTH OF VALMY. solution of limestone rock in Door County is small areas of limestone pavement. These areas look like patios or courtyards, because their surface consists of flat, rectangular blocks of smoothly rounded bare rock that are separated by crevices a foot or so deep. The rock was scraped bare by glacial ice, and solution has widened the original cracks in the rock into crevices. Limestone pavements are less common than they once were, because thoughtless people have excavated the smooth rock to pave their terraces and patios, and the rest of us can no longer enjoy them.

The solubility of the limestone rocks of Door County and the thin soil that mantles them have created massive problems of wastewater disposal and groundwater contamination. The environment is almost ideal for polluting groundwater.

The soils are too thin to filter pollutants, and groundwater flows so erratically and unpredictably through the soluble rock that it is virtually

impossible to identify sources of contamination or to know whether the water is fit to drink. All wells must be tested annually, and many people prefer to drink bottled water as a safety precaution. This physical environment forces residents of Door County to learn more than they really want to know about septic systems, mounds, holding tanks, and wastewater management generally.

SOLUTION OF LIME-
STONE ROCK AT PLUM
BOTTOM HILL NEAR
CARLSVILLE.

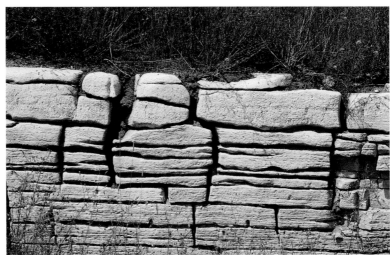

LIMESTONE PAVEMENT.

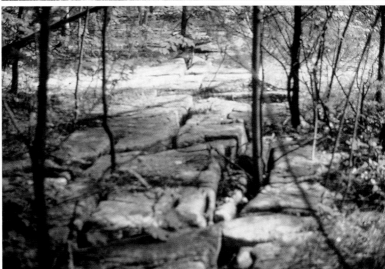

Metropolitan newspapers periodically carry scare stories about episodes of serious gastrointestinal epidemics accompanied by vomiting, diarrhea, abdominal cramps, nausea, high fevers, and body aches that have resulted from drinking polluted water or from swimming in it. Beaches in state parks have been closed because of high E. coli levels that might have been caused by bird droppings, diaper changing on the beach, dumping of sewage by boats, flawed campground toilets, flawed onshore sewage systems, or other sources that we do not even know.

Before 1960, some wells in the county were inadvertently polluted by cherry growers, who sprayed their orchards with a powdered pesticide of lead arsenate and copper sulfate. They mixed the powder with lime and water at mixing stations near their orchards and stored it in overhead tanks from which they could easily fill the spraying machines. Inevitably, some of this mixture was leaked or spilled. The area north of Sturgeon Bay has thirty-eight known pesticide mixing stations, and the soil and a few wells near some of them still have traces of lead, copper, and arsenic.

The safe disposal of domestic waste remains a major challenge in Door County, and the problem is aggravated as the number of visitors increases. Before 1940, most homes and even some hotels had backyard privies, and the privies in the crowded seasonal labor camps that housed cherry pickers were notorious. Some privies were too close to wells, and drinking water often was polluted, but people grimly accepted waterborne diseases as an inevitable fact of life.

The development of indoor plumbing resulted in copious quantities of household wastewater that had to be disposed of, and most homeowners invested in septic systems. In recent years, many homes have added washing machines, dishwashers, and garbage disposals, which have greatly increased the volume of wastewater. In a septic system, all wastewater is flushed into an underground tank, where the solids settle to the bottom to form sludge, and the grease floats on top to form a

layer of scum. Bacterial action in the tank partially decomposes these solids, which must be pumped out every two to three years.

The effluent liquid flows into a system of perforated pipes laid in trenches filled with gravel. From these pipes it seeps into the soil, where bacterial action breaks down pollutants before it enters the groundwater and flows into wells. A septic field is about twenty inches below the surface, and it needs at least thirty-six inches of soil beneath it to filter the effluent adequately, so a conventional septic system must have at least fifty-six inches of soil to operate properly. Only one-quarter of the soils of Door County are this deep (see Fig. 4), which suggests that the development of appreciable areas will be seriously restricted.

Another quarter of the soils of Door County are deep enough for distinctive mound systems, which were developed in Wisconsin, but are not even permitted in some states. They are inescapable features of the landscape. A mound is five feet high and thirty to fifty feet long or longer, depending on the number of bedrooms in the house. Small inspection pipes peep from either end. A pump moves effluent water from the septic tank to the top of the mound, which is filled with layers

SEPTIC MOUND.

of gravel and sand that filter it enough so that only twenty-four inches of soil are necessary beneath a mound.

Advanced wastewater treatments systems have been developed that require only six inches of soil, but these systems are extremely expensive, and eighteen percent of the county has soils so thin that they are unsuitable for any onsite soil disposal of treated wastewater. These areas must have holding tanks that store wastewater but do not treat it. Building a holding tank necessitates blasting a hole in the bedrock, and tanks must be pumped out every two or three weeks into redolent trucks that haul away the waste.

Holding tanks are systems of last resort, and they are highly controversial. They have permitted the development of housing in areas that hitherto were unsuitable, and they obviously are more appropriate for seasonal than for year-round homes. In 2005, Door County had more than 3,500 holding tanks, the greatest density per square mile of any county in Wisconsin, and the number is increasing.

In 2002, the county began a survey of all private, onsite waste treatment systems. The owners are given one year to replace any that are not up to code, but the progress of this survey has been agonizingly slow, because the soil must be tested at each site. Nine cities and villages in the county (Baileys Harbor, Egg Harbor, Ephraim, Fish Creek, Forestville, Institute-Valmy, Maplewood, Sister Bay, and Sturgeon Bay) have been able to develop their own piecemeal sewage systems and treatment plants, but their construction has been difficult and expensive, because it requires blasting trenches in the limestone bedrock.

If development continues, as it assuredly will, the Niagara limestone is going to force Door County to create an effective regional wastewater treatment system, and the cost of such a system will be astronomical.

No place in Door County is more than eight miles from Green Bay or Lake Michigan, and the county has always looked to their waters. Until 1870, and even later, most settlers clung close to its 250 miles of shoreline, because the peninsula bore a dense, virtually impenetrable forest, and hewing a trail through the woods was a truly herculean task. Travel by boat in summer or over the ice in winter was much easier than travel overland.

Before the advent of automobiles, contact with the larger world was by water. Door was the last county in Wisconsin to have a railroad, and the railroad that finally was completed in 1894 was not competitive. For people on the bay side of the peninsula the twin towns of Marinette and Menominee, on the west side of Green Bay, were more accessible than the city of Green Bay or even the town of Sturgeon Bay, and the metropolis for the lake side was Manitowoc, Milwaukee, or even Chicago.

As early as 1866, the city of Green Bay had regularly scheduled steamship service to Chicago, and steamships on the Chicago to Buffalo run often stopped at piers in Door County to take on the loads of cordwood they needed to fire their boilers. The Sturgeon Bay Canal was opened in 1881, and thereafter the Chicago to Mackinac summer steamers stopped at Sturgeon Bay, Fish Creek, Ephraim, Sister Bay, and Washington Island. In addition to four regular steamship lines,

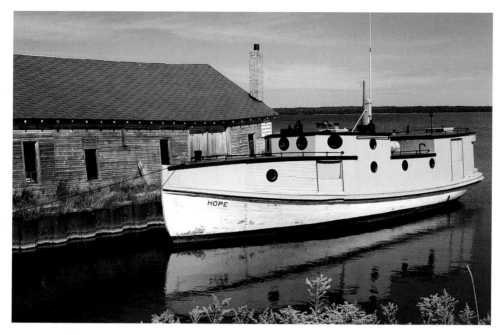

wrote Hjalmar R. Holand in 1917 (page 85), "a number of nondescript FISHING BOAT.
hookers plied along the shore, buying forest products and fish and
returning with sundry necessities of life."

Groups of Indians frequented the shores of the peninsula long
before the arrival of white men, but their settlements were merely fish-
ing villages, and Indians have left scant trace on the contemporary
landscape. Early archaeologists identified more than 150 Indian "sites"
in Door County, but most have been obliterated by subsequent cultivi-
ation and construction. Archaeologists have puttered about a few of
these sites, but much of their knowledge of Indian life on the peninsula
is deduced from other areas in northeastern Wisconsin. Apparently,
the Indians lived in simple wigwams covered with mats of birch bark,
used stone and bone tools and implements, and fished with hooks,
spears, and possibly nets. They might have tilled small plots of corn,
beans, and squash, but the dense forests kept them from penetrating
very far inland.

The first white men who lived along the shores of Door County were fishermen. As early as 1836, they had camps on Washington Island, where Indians had been fishing for centuries. The fishermen caught whitefish, salted them down, and packed them in 100-pound barrels that were carried by boat to Cleveland, Chicago, and other cities along the Great Lakes.

The fishermen needed safe havens for their small boats, and in 1838 the first lighthouse was built on Rock Island to guide them to safety. Eventually, seventeen picturesque lighthouses (Fig. 5) have been built on the rocky shores of the county to help mariners navigate the treacherous waters around it. Each lighthouse must be distinctive to enable sailors to recognize it from far out on the water.

The fishermen had potbellied stoves on their stubby little boats to keep them warm, and for their meals they boiled fish, potatoes, and onions in pots on these stoves. The fish boil subsequently has moved on shore, and it has become a trademark of Door County. Every tourist area needs a trademark food to which visitors feel compelled to subject themselves at least once, and the Door County fish boil is comparable to the Cape Cod clambake or the Hawaiian luau.

LIGHTHOUSE IN PENINSULA STATE PARK.

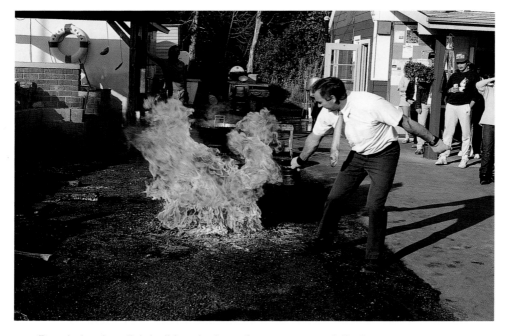

People begin a fish boil by placing a large open pot full of water over a roaring wood fire. They lean long slabs of wood against the pot to direct the heat upwards, and pour salt into the water to make impurities float to the surface. When the water boils they lower into the pot a perforated stainless steel basket filled with onions and small red new potatoes. After eighteen minutes they lower into the pot a smaller steel basket full of whitefish, and seven minutes later they throw a pint of kerosene on the fire to create a spectacular boilover. The flames roar up, the pot boils over, and great clouds of steam billow from the fire. Then workers remove the fish, potatoes, and onions from the pot and serve them with lashings of melted butter. You top off the meal with a slab of delectable Door County cherry pie.

Fish boils remain a staple on the menus of many eating places in Door County, but commercial fishing has been transformed into a modern business and concentrated in fewer and fewer hands. The number of commercial fishing licenses in Wisconsin dropped from 236 in 1979,

to 143 in 1989, and to only sixty-nine in 2005, of which twenty-seven were in Door County. The principal commercial fishing ports in the county are Gills Rock and Baileys Harbor.

The Wisconsin Department of Natural Resources (DNR) regulates fishing in the state. In 1989, the DNR introduced a quota system for commercial fisheries to enable it to manage the fishery resource more effectively. Each year it determines the amount of whitefish, perch, chub, and smelt that may be caught in Green Bay, in northern Lake Michigan, and in southern Lake Michigan, and it assigns each licensed fisherman a quota, which is the amount of a particular species he can harvest in a particular area.

The quota is in pounds, but it is based on the percentage of the species that the fisherman caught in the area in a specified historic time period. Owners may sell their quotas, either annually or permanently. Some fishermen have sold their quotas, because they are so small or because no other members of the family are interested in carrying on the business, while other fishermen have bought quotas to expand their businesses. Modern fishermen have a lot of money tied up in their businesses. Many of them operate several boats, and have expensive processing facilities. They fish extensive areas with gill nets and entrapment nets.

A gill net is made of mesh that allows the head of a fish to pass through, but entangles its gills when it tries to escape. The net has floats on top and lead weights on its base that make it stand like a gigantic, underwater tennis net (Fig. 6). Modern gill nets are more than a mile long, and sometimes fishermen set them in gangs of five or more. They have marker buoys at either end, usually with two orange or black flags on a five-foot pole on the buoy closest to shore and a single flag on the deepwater buoy.

Fishermen go out each day in stubby little boats to collect the fish that have become entangled in their gill nets. Things of beauty these boats are not, but they are perfect for their task. They are low in the

water and wide on the beam, with plenty of working room. Behind the door on the left front side is a hydraulic netlifter, which hauls the net out of the water onto a stainless steel working table inside the boat. The fishermen adroitly remove the fish from the net, ice them down immediately, and toss any undesired species back into the water through the door on the right front side of the boat.

After they have removed the fish from the gill net, the fishermen reset it by feeding it out through the door in the back of the boat. It separates nicely when the weighted line sinks and the top line floats. If it has not caught enough fish at one site, the fisherman can easily move it to a new site where he thinks there are more. Gill nets seem to cluster in the same locations at the same time each year. At the end of the season, and perhaps more often, the fisherman must haul the gill net from the water and roll it up on a large, picturesque reel where he can wash and mend it.

Entrapment nets come in various versions, but they all have long lead nets at right angles to the shore that direct fish into a potholding section from which they cannot escape (Fig. 7). Pound (pronounced "pond") nets have open-top pots supported by anchor poles that rise

above the water; other types have submerged pots with closed tops. The fisherman lifts the potholding section high enough in the water so it is easy to scoop out the fish, and it is easy to return incidental catch to the water. A fish that has been able to swim around in a pot, no matter how constricted, presumably is less stressed and tastier than one that has been entangled in a gill net for up to twenty-four hours.

The gill net season is from March through July, and then fishermen set their big pound nets in September and October. Whitefish is the big money fish in Door County, and some biologists believe that Moonlight Bay, the next bay north of Baileys Harbor, is the principal whitefish spawning area on Lake Michigan. The fishermen normally go out to lift the fish around six o'clock in the morning, and they are back around noon. Some whitefish is smoked, but in summer much of it is used for fish boils, and it is desirable to deliver it to the restaurant as fresh as possible.

Dennis Hickey, who was born in 1942, and his brother, Jeff, have developed a modern fishing business in Baileys Harbor, where their family has been fishing since 1852. The Hickey brothers started fishing in the early 1960s, when they caught alewives for pet food, fish oil, and

DENNIS HICKEY.

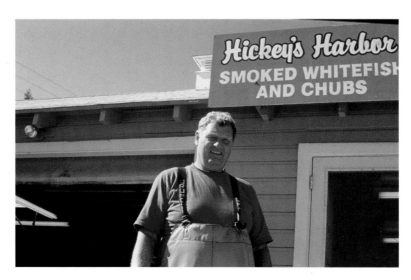

fish meal, but they switched to whitefish when whitefish started to ONE OF DENNIS HICKEY'S FISHING BOATS.
come back in the late 1960s.

The Hickey brothers have eight fishing boats. In July, six were in the lake and two were in the bay, but they come and go, depending on where the fish are. Dennis said they use every type of gear that's legal. They set gill nets in the lake and in the bay in spring and summer, and they set big pound nets in the lake in the fall. They sell their catch to a wholesale fish house.

The brothers, their wives, and their son-in-law each has a commercial fishing license, which they need for different quotas, areas, and types of nets. They need multiple licenses, because the DNR quota program is based on the old, traditional idea of one fisherman: one boat, one license; and one quota, and it is poorly adapted to large, modern fishing operations. Dennis added that it would be easier to sell a single license if they ever decided to sell off part of their business.

He said that he and Jeff could retire now if they wanted to, but they are having too much fun to stop. They have contracts to conduct

assessment research for the Wisconsin DNR and the U.S. Fish and Wildlife Service in Montana and Idaho, where they catch, tag, and release the desirable species; they grind up the undesirable species and dump the remains back in the lake. The Hickeys also do a flourishing business cleaning, vacuum-packing, and freezing game fish that sports fishermen have caught.

Commercial fishermen have surprisingly little conflict with sports fishermen, because they seek different species. Sports fishermen want trophy fish, such as chinook salmon, rainbow trout, brown trout, coho salmon, and lake trout, which fight vigorously, leap spectacularly from the water, and look impressive when they are mounted on the wall. Some sports fishermen have their own boats, but others hire charter boats that are based in Sturgeon Bay, Gills Rock, and Baileys Harbor.

Sports fishermen are far more numerous than commercial fishermen, and their greater numbers give them considerable political influence. Public agencies have attempted to restock some species of sports fish for them, but they have left commercial fishermen to fend for themselves. Some people suspect that the state of Michigan has been responsible for the decline of the perch population, because it has

A CROWDED MARINA
AT STURGEON BAY.

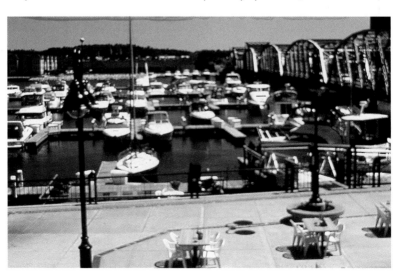

restocked Green Bay north of Menominee with walleyes, which are ferocious predators.

Door County patently is a great place for those who like to fish, but it is equally great for boaters who never wet a line. The peninsula still turns its face to the water, and its harbors are crammed with watercraft of every size and description, from luxury power boats and huge sailing yachts, to tiny jet skis, canoes, and kayaks. Every harbor has marinas, mostly for yearly rental, but with a few slips to rent to transients.

Every boat that has a sail or motor must be registered with the DNR. In 2003, Door County had 6,595 registered boats, which of course does not include those that are registered elsewhere and hauled in to the county. On summer weekends the roads to and from the peninsula are clogged with vehicles towing boat trailers, some moving entirely too fast and others moving so slowly that they generate considerable antipathy.

From the very earliest days shipbuilding has been an important activity in the county. Everyone had to have a boat, and the peninsula had plenty of good wood with which to build them. The first steel ship built in the county was not launched until 1924. The largest shipyards have always been in Sturgeon Bay, which has become the leading shipbuild-

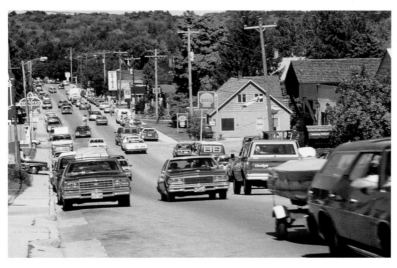

SUMMER TRAFFIC
IN SISTER BAY.

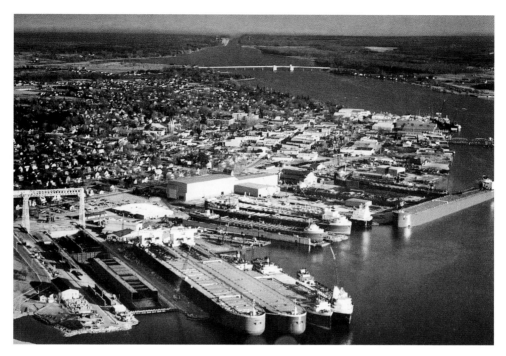

ing center on the U.S. side of the Great Lakes. Shipbuilding is a risky and uncertain business, however, and the names of shipyards and their owners have changed repeatedly as companies have come and gone.

The shipbuilding business in Sturgeon Bay peaked during World War II, when 5,000 workers built 258 ships in local yards, but since then the fortunes of the industry have fluctuated from a high of more than 2,500 workers to a low of fewer than fifty. The top news story of the year in Door County in 2004 was the massive resurgence of the shipbuilding business, which has remained prosperous. Welders, electricians, pipefitters, boilermakers, carpenters, and other highly skilled workers commute to the shipyards from as far away as Green Bay, Kewaunee, and the northern tip of the county. A new Shipbuilding Cluster Project is designed to modernize existing facilities, to encourage companies that supply the shipbuilding industry, and to make the shipyards a more attractive tourist destination.

The shipyards of the Bay Shipbuilding Corporation are along the waterfront north of downtown Sturgeon Bay. There are eight piers where large lake boats can tie up, a floating drydock 604 feet long and seventy feet wide, and a graving (dry) dock 1,158 feet long and 140 feet wide (Fig. 8). An enormous gantry crane 156 feet high with a capacity of 200 tons straddles the graving dock and runs on tracks along both sides of its entire length.

Entire sections of ships are prefabricated as modules in huge shops on the yard, transported to the graving dock, and placed on ships by the gantry crane. The yard builds and repairs a wide variety of commercial and military craft, from large lake freighters and ocean-going tugs to mundane fishing boats and dredges, and each winter fifteen to twenty lake boats tie up for routine maintenance, repairs, upgrades, and conversions. The winter layup season lasts for sixty to ninety days, from January through March. The yard has been building double-hulled barges for transporting oil, since they have been required by the Oil Pollution Act of 1990, which was passed after the disastrous Exxon *Valdez* oil spill in Alaska.

Sturgeon Bay is also home to the Palmer Johnson Company. In 1918, Palmer Johnson began to build fishing boats, and in 1928 he built his first yacht. The company has grown into one of the world's leading builders of luxurious high-speed motor yachts. Each one is unique, and each one requires painstaking attention to detail. The company can build only four or five a year, and they sell for $12 to $20 million and up to people who can afford to pay that kind of money for their toys. Its business has been so successful that in December 2005 the company announced plans to build a mammoth new 310-by-700 factory sixty-five feet high on the west side of the bay south of the Michigan Street bridge.

For those of us whose wallets are appreciably lighter, the waters that embrace the Door peninsula are still one of its principal attractions, but they are an elusive attraction. Although the peninsula has a number of public beaches and boat launching sites (Fig. 5), the private owners of resorts and cottages have preempted most of its shoreline, and access is seriously restricted. The price of shoreline property is truly astronomical, and the owners zealously protect their prerogatives. They cannot legally fence a beach, but they can discourage visitors by erecting signs that say, "Private Beach. No Trespassing," and such signs are distressingly ubiquitous in Door County.

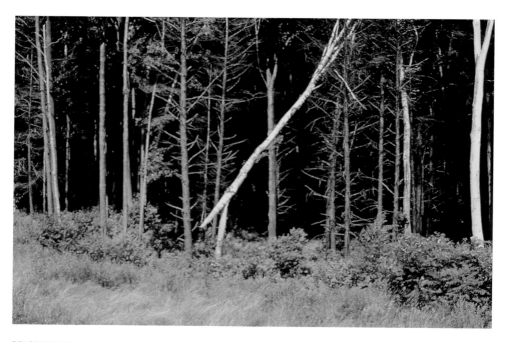

DENSE FOREST.

Door County is naturally a wooded area. Early settlers felled the primeval forests for building materials and for fuel, and they pulled out the stumps to prepare the land for cultivation. In some old photographs, the landscape looks surprisingly naked and treeless to a modern eye, because second-growth woodlands now cloak much land that once was open. Old Mother Nature has foreclosed her mortgage and healed the wounds that people inflicted on the land if the owner has not cultivated or mowed it regularly.

Dense dark forests covered the Door peninsula when white people first visited it in the 1850s and 1860s. Some wooded areas in modern state parks and nature preserves give a sense of how dense they were. They were northern mixed forests, because the peninsula is an ecological tension zone where broadleaved tree species such as ash, aspen, beech, birch, maple, and oak, are competing with needleleaved species such as cedar, pine, spruce, and hemlock.

In detail, the peninsula is a crazy quilt of ecological niches where some species can compete more effectively than others, and it had no pure stands consisting of only a single tree species. Forests of beech and maple probably were most common in the interior of the peninsula, while alder, cedar, and tamarack dominated the swamps on the eastern side. Some people think that a large part of the county was covered with white pine trees three to four feet in diameter, but these trees probably were only a single component of a complex mixed forest.

The National Natural Landmark nature preserve at Toft's Point north of Baileys Harbor has one of the few remaining stands of old-growth white pine on the shores of Lake Michigan. Thomas Toft, a Danish immigrant, settled here in the late 1870s and never allowed the trees to be logged. His daughter, Emma, came back after her father died and built five rustic log cabins that she rented to summer visitors, but she defiantly protected and preserved the natural character of the area, and

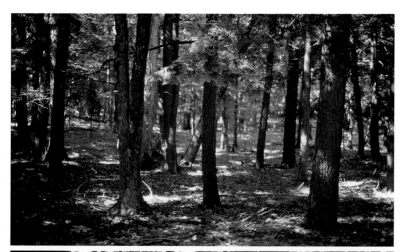

HARDWOOD FOREST AT PENINSULA STATE PARK.

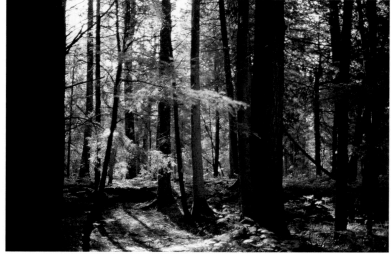

OLD-GROWTH FOREST AT TOFT'S POINT.

she deeded it to the University of Wisconsin-Green Bay for a natural classroom and research site.

The dense mixed forest of the peninsula attracted lumbermen, who built sawmills at sheltered sites along the shore and recruited immigrant woodchoppers to fell the trees and work in the mills. Sawmills provided impetus for the early growth of Sturgeon Bay, which had three in 1855. The area north of Sturgeon Bay probably had the densest growth of white pine forests on the peninsula.

Most sawmill owners built long piers that extended hundreds of feet out into the lake or bay, to deep water where ships could load cargoes of logs, lumber, telephone poles, railroad ties, fence posts, shingles, and cordwood for steamship fuel. Less maneuverable sailing ships could tie up at a buoy another 400 to 500 feet out and winch themselves in to the pier. In 1900, Door County had more than sixty piers; the longest, at Clay Banks, in the far southeastern corner of the county, was 1,600 feet long. Few of these piers have withstood the ravages of time.

The piers had to be sturdy enough to withstand intense ice pressure in winter, which can wreak havoc with human works along the

PIER ON STONE-FILLED LOG CRIBS.

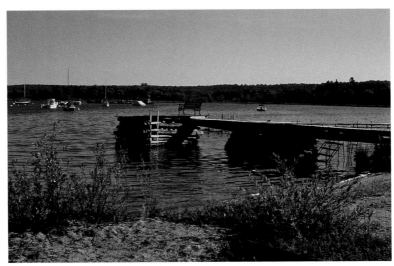

shore. Men made piers by building cribs of logs, towing them into position, filling them with rocks, and building bridges between the piers. Many piers had storage warehouses at their deepwater ends, where the boats tied up, and onshore were the sawmill, a general store, a blacksmith shop, a boarding house for the workers, and perhaps a saloon or hotel with rooms for rent to travelers. The Anderson dock and store in Ephraim are a fine example of a traditional pier and general store.

Long rows of cordwood lined the shorelines near the piers. Lumbering was the principal business of the county from 1870 until 1890, but the lumber market was highly volatile, and in poor years many sawmills went broke. The business peaked around 1880, by which time most of the valuable white pine had been cut, and by 1890 most sawmills had closed down. Today, there is little trace of them.

On the eastern side of Door County lumbermen built corduroy roads back into the cedar swamps. They laid logs side by side at right angles to the direction of the road, and spread gravel over the logs to

smooth out the bumpy roadbed. Corduroy roads have actually caught fire and burned. Some unpaved back roads still are underlain by corduroy logs that once showed through at the surface when the road grader had scraped them bare or when they had rotted away, but in recent years the county highway department has covered most of them with deep layers of gravel, and the logs are no longer obvious.

Almost every original land entry in Door County was made by lumbermen. They took only the best trees, such as white pine, and then sought new forests to exploit. They were only too happy to sell their land to some of their woodchoppers, who had decided to stay on and try to make a living by clearing and farming it. In their first years, these would-be farmers derived most of their income from cutting and selling the trees that the lumbermen had scorned, such as beech and maple for cordwood, or cedar for posts and shingles. During the long winter nights many families cut cedar shingles in their homes.

Eventually, the settlers cleared most of the primeval forest. As early as December 23, 1905, the *Door County Advocate,* perhaps with a bit of exaggeration, asserted, "It is a good thing that the demand for cordwood has fallen off during the past years, otherwise the timber that is left in this county would all be destroyed in the near future."

The early settlers built their homes, barns, and all other buildings of logs they had cleared from their land, and fire was always a threat. The Ephraim correspondent once reported to the *Door County Advocate,* "the Nelson barn burned last night. Neighbors either watched, were frightened by, or slept through the terrifying midnight event." That description seems to leave very few alternatives.

Most of the early settlers had come from countries in northern Europe, where log construction was the norm, and they knew how to build with logs. The exceptions were the Belgians in the southwestern part of the county, who came from brick country and were never comfortable with logs. They did their best to construct log buildings, but they used inferior wood, such as gnarled cedar. Many Belgian log

buildings look like they were built by people who had heard of log buildings but had never actually seen one.

Some people read significance into the way the logs are joined by notches at the corners of log buildings. They have speculated that members of different ethnic groups employed unique types of notching, and certainly there is a wide variety, but it seems that the type of notching was determined as much by the technical competence of the builder as by his ethnicity.

Log houses fell from fashion for many years, although recently they have returned. The people who built them thought they were primitive, old-fashioned, and a source of embarrassment. They built more modern houses as soon as they could afford to do so, or at least disguised the outer log walls with up-to-date siding. An unknown, but probably large, number of the older houses in rural Door County are log structures covered by later siding. The only way to learn whether they are log is to interview the owner or tear off some of the siding, and most owners take a very dim view of the latter form of scientific research.

In recent years, log buildings have become chic, and city folk have had fun finding and renovating them. Usually, the chimney and chinking need to be replaced, and installing modern wiring in solid log walls can be a challenge. People who cannot find old log houses to renovate can hire contractors to build them from scratch. Some of the new log houses are self-consciously garish, as if to advertise the fact that they really and truly are log buildings, but others are so demure that they look as though they have been standing for a century or more.

Door County is one of the very few areas in the United States that has buildings with stovewood walls. The builders made them by sawing small logs into pieces of stovewood length, a foot or so long, and stacking the pieces in wet lime mortar at right angles to the length of the wall. The round ends of the logs are exposed as circles in the wall, although sometimes they were covered with plaster. At the ends of the walls the builders made corner bracing posts by stacking alternating

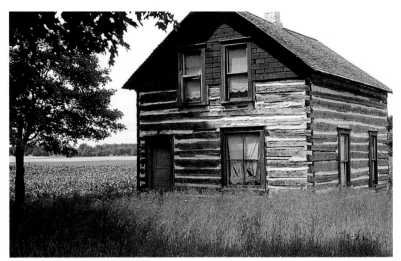

OLD LOG HOUSE NEAR
CARLSVILLE BEFORE
(TOP) AND AFTER
(BOTTOM) RE-SIDING
AND RE-ROOFING.

layers of logs at right angles. Some of the finest examples of stove-
wood walls in Door County are in the Potter's Door Pottery bed and
breakfast on State Highway 57, four miles south of Sister Bay.

Stovewood construction was used mainly for interior walls, because
air leaks easily through the pores in the logs. Most of the county's
stovewood buildings are on the eastern side near the cedar swamps,

where the trees were too small for conventional log construction. The STOVEWOOD CONSTRUCTION. idea of using undersized logs to make stovewood walls probably was brought to Door County by immigrants from Norway, where stovewood construction was common in poorer districts. Most of the stovewood buildings in the county are more than a century old.

During the last half-century, much former farmland in the county has grown up in trees, because farmers have been using it less intensively. Open land that they do not cultivate or mow will revert to woodland in only a few decades, and many fields, especially in the northern part of the county, are in various stages of succession to woodland. The first stage is rank growth of knee-high meadow grasses, with a magnificent profusion of wildflowers. Then, grim, dark juniper bushes begin to expand like loathesome warts, and saplings start to show their crowns above the grasses, which they eventually shade out. As but one example, the *WPA Guide to Wisconsin* (page 317) said that, in the 1930s, "the view south from the hilltop north of Ephraim is one of the

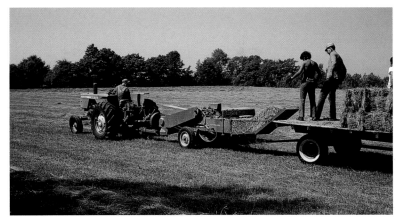

THE SAME FIELD IN
EPHRAIM IN 1970
(TOP), 1986 (MIDDLE),
AND 2000 (BOTTOM).

finest in the state," but since 1980 that superb view has been completely obscured by the growth of trees along fencelines and in abandoned fields.

Mother Nature wants Door County to be wooded, and particular species of trees are especially well adapted to each ecological niche in the county. The specific variety of tree that will populate a given area, whether conifer, hardwood, or some mixture thereof, will be determined by the proximity of seed species, by the mechanics of seed dispersal, by the wind or by animals that ingest seeds in one place and excrete them in another, and by the ability of each species to compete with and crowd out others. The details are unpredictable, but we know that Door County will be wooded unless people interfere with nature.

Most of the early farmers in Door County were immigrants who had come to work as woodchoppers in the woods and sawmills and decided to stay. They bought land from which the lumber companies had "high-graded" the best trees, but plenty of other trees remained, which was fortunate for them, because much of their income in their early years came from sales of cordwood and shingles made from trees they had cut on their own land.

Few farms were larger than forty acres, which is smaller than many modern fields. The farmers could have acquired much larger acreages, but to immigrants from Europe forty acres seemed like a princely estate, and clearing forty acres by hand took a long time. Felling trees, pulling out stumps, lugging rocks to the fence line, or heaping them in piles in the fields required such prodigious efforts that farmers cleared only four to five acres at a time.

Wheat was the pioneer cash crop. It was easy to grow even amidst the stumps on newly cleared ground. Most farmers grew oats and hay for their horses and cattle, and a few tried to grow corn, but the varieties available required such a long growing season that the crop often was killed by frost before the kernels had time to ripen. Everyone had a vegetable garden with lots of potatoes, which were the staple diet.

The early settlers threshed wheat with hand flails, and they needed barns where they could work under cover. Each grain of wheat

is protected by a tough, inedible husk that must be removed before the grain can be milled. Beating the grain to remove the husks is called threshing. When the grain was ripe the farmer cut the stalks with a heavy scythe, tied them into bundles called sheaves, hauled them to the barn, spread them on the threshing floor, and beat them with hand flails to free the grain.

A hand flail has a sturdy wooden handle three- to four-feet long whose end is bound by a loop of leather to a shorter and heavier wooden cudgel. A worker could swing the handle over his head and bring the cudgel down on the grain with great force. All wheat was threshed with hand flails before threshing machines were invented. Hand flails have virtually disappeared, although the Door County Museum in Sturgeon Bay has one example. They are not impressive enough to interest antique collectors, even though in their day they were essential farm implements.

Farmers threshed wheat on transverse wooden floors in the centers of rectangular barns, where they could work in all kinds of weather. The barns had large double doors on either side that could be opened to let wind blow away the chaff. This type of barn is called a Three-Bay Barn, because it has open storage bays in the ends on either side of the central threshing floor. Early settlers brought the idea of the Three-Bay Barn with them from Europe. Some people call them "English" barns, which is a mistake, because they were just as common north of the border in New France (modern Quebec) as they were in New England.

Farmers had to change their barns significantly when they shifted from wheat cultivation to dairy farming. On small farms they created Modified Three-Bay Barns by building solid sheds for their cows and workstock in one end bay, and they stored hay in the other end bay and in the loft above the animals. On larger farms they jacked up the entire Three-Bay Barn and created a Raised Three-Bay Barn by building beneath it a solid masonry ground floor with numerous windows. They kept their animals on the ground floor and stored hay in the loft above

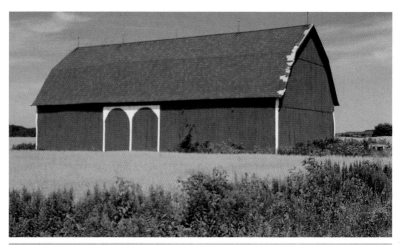

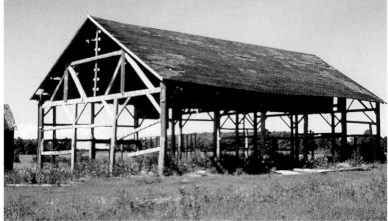

THREE-BAY BARNS.

them. The first Modified Three-Bay Barns and Raised Three-Bay Barns were experimental, but they worked so well that soon farmers were building them from scratch.

After a few years, wheat yields began to decline, because continuous cultivation of the crop exhausted essential plant nutrients in the soil, and the buildup of parasites in the soil reduced yields even more, so farmers were forced to find a new source of income. They experimented with various other crops, but after 1880 most of them began to concentrate on producing milk, and they grew crops to feed their dairy cows.

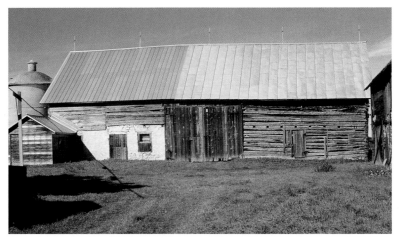

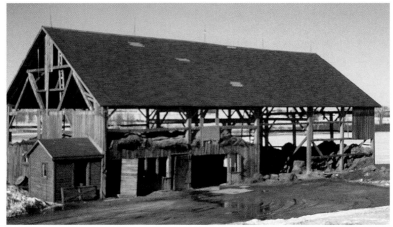

MODIFIED THREE-BAY BARNS.

Dairy farmers practiced a three-year crop rotation that was economically successful and ecologically sound. In the first year, they planted corn, because they had learned that they could harvest it for silage while the kernels were still unripe, before the first frost caught it. They chopped the entire plant into pieces no larger than your little finger and blew them into a towering cylindrical silo. In the second year they planted oats, which they needed to feed their work horses, and they planted alfalfa at the same time in the same field where they planted oats. It is difficult to establish a good stand of alfalfa by planting the seed on bare ground; the

42

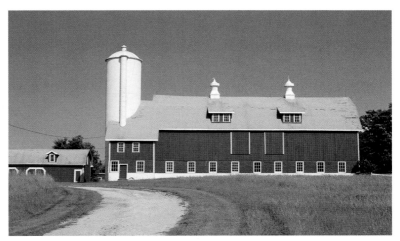

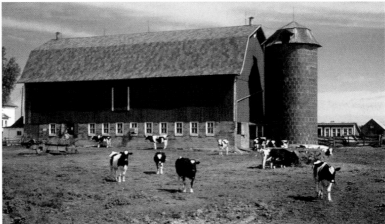

growing oats were a protective nurse crop for the young alfalfa plants,
which had become sturdy enough to stand by themselves by the time the
oats were harvested. Alfalfa is a perennial. In the third year, the farmer
mowed and dried the alfalfa for hay, and because it is also a legume it
enriched the soil with nitrogen for the corn crop that began the next cycle
of the three-year rotation. Alfalfa hay and corn silage are an almost com-
pletely balanced ration for dairy cows.

Dairy farmers had to build new barns to shelter the valuable milk
cows that had become their principal source of income. Most built

larger versions of Modified Three-Bay Barns. In the masonry end, they built stalls for twelve to fourteen cows, which was about all they could milk by hand, and the other end had a larger loft for alfalfa hay. Beside the barn they built one of the cylindrical cement silos for corn that have become the hallmarks of Wisconsin dairy farms. The first silo in Door County was built in 1885; by 1920 farmers were adding twenty new silos a year to the rural landscape of the county.

Door County is too far from any city to have any market for its fresh milk, so farmers sold their milk in the form of cheese and butter, which the farm women and girls made in the farmhouse kitchen in the early days. They made cheese by adding rennet, the membrane of a calf's stomach, to whole milk to make curds coagulate from the watery whey. They removed and processed the curds to make cheese, and the men fed the whey to hogs.

The women and girls made butter by skimming the cream off whole milk; the skim milk was fed to hogs. The women placed the cream in a churn and worked it until their arms and shoulders ached. When globules of butter finally formed in the thick buttermilk, they skimmed them out with wooden paddles, salted them heavily, and packed the butter in crocks or kegs to take to the store to sell. Some people fed the buttermilk to hogs, but others liked to drink it themselves.

The farm wife took cheese and butter to the local store, where she bartered them for things the family needed. The butter often spoiled, even though it was heavily salted, and people complained that it was inedible and could be used only for grease. Farmers and storekeepers were constantly trying to one-up each other. M. Marvin Lotz in 1994 (page 196) told the tale of an angry housewife who stormed into a store complaining about a stone she had found in sugar the storekeeper had sold her. He took it from her, examined it carefully, and then commented that it looked exactly like the stone he had found in the crock of butter she had sold to him the week before.

Dairy farmers soon realized that they had to improve the quality of their products, so they cooperated to build creameries that would manufacture butter and cheese. Farmers hauled their milk to the creamery in large, heavy metal cans, and took home skim milk and whey for their hogs. People once joked that every crossroads in Wisconsin seemed to have a creamery, with a tavern across the road.

In 1916, Door County had twenty-nine creameries, mostly in the more productive farming areas in the southern part (Fig. 9). The number

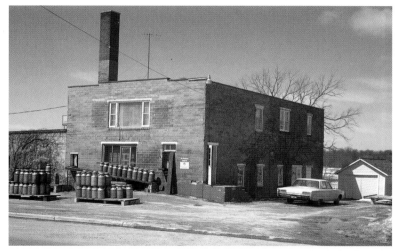

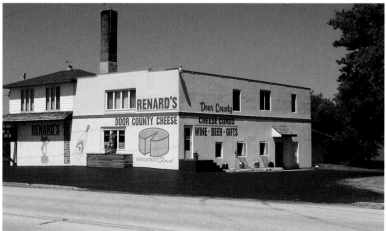

RENARD'S CREAMERY AND CHEESE FACTORY NORTH OF BRUSSELS BEFORE (TOP) AND AFTER (BOTTOM) IT WAS CONVERTED TO A STORE AND RESIDENCE.

of creameries fluctuated over the years, and finally declined when transport to distant milk processing plants became easier and cheaper. The only remaining creamery in Door County is Renard's Cheese in the far southwestern corner on County Highway S; the Renards have also converted a former creamery on State Highway 57, seven miles south of Sturgeon Bay, into an outlet store.

Dairy farmers began to expand their milking herds to around forty cows when milking machines became available after World War II, and they had to enlarge their barns. Some extended the livestock end of their Modified Three-Bay Barns at right angles to create an L-shaped ground plan, but others merely extended it in a straight line to make a longer barn. Some farmers built completely new Raised Three-Bay Barns, which had become standard on Wisconsin dairy farms, with a large hayloft on the upper level above a masonry ground floor with stalls for forty cows and a silo at one end.

Farmers who expanded their milking herds also had to farm more land, both to grow crops to feed their cows and to use their machinery efficiently, and they gradually increased the size of their farms. Some farmers bought land, but farmland is so expensive that most farmers preferred to enlarge thair farms by renting land from neighbors who had stopped farming it. Modern farmers have become part-owners; they own part of the land they farm and rent the rest. The competition for land to rent is so intense that they often have to travel considerable distances to find it.

The number of dairy farms in Door County has steadily dwindled as their size has increased and smaller farms have stopped milking (Fig. 10). Between 1950 and 1990, which was probably the golden age of dairy farming in the county, the 160-acre farm with forty to sixty milking cows and an equal number of young stock became the paragon that provided a comfortable level of living for a complacent farm family.

Too complacent, in fact, because Wisconsin dairy farmers have been blindsided by a new technology of dairying that was developed in

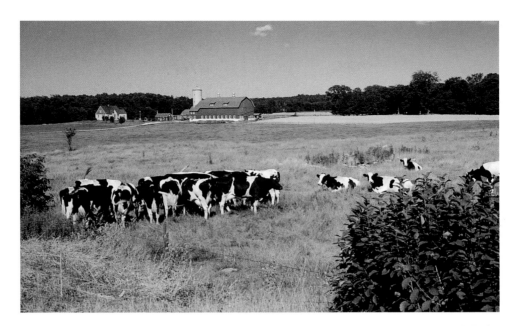

DAIRY FARM WITH A
FORTY-COW DAIRY
BARN NORTH OF PLUM
BOTTOM HILL NEAR
CARLSVILLE.

California after World War II. The new operations are called drylot dairies, because herds of 500 cows or more are confined in small corrals where all of their feed is delivered to them; they never set foot on pasture. Three times a day they walk in groups of twenty-four to fifty to a milking parlor, where workers milk the entire lot in fifteen minutes and send them back to the drylot to eat some more. The genius of the drylot system is its economies of scale. It can produce milk more cheaply than conventional dairy systems.

The drylot system of confined feeding with large numbers of cows has gradually been adopted in other parts of the country, even though it costs a lot of money. A modern family dairy farm must milk at least 500 cows in order to provide an acceptable level of living for a contemporary American family. A 500-cow dairy requires an investment of $2.5 million, and no bank will lend more than eighty percent, so the farmer who wants to start a modern dairy farm must be affluent enough to make a down payment of half a million dollars and courageous enough to take on a debt load of two million more. Few forty-

cow dairy farmers are in that ballpark, and they can no longer compete with those who are.

Those dairy farmers who have made the great leap to the drylot system of confined feeding have had to modify it slightly. They use the same kinds of herringbone milking parlors as in California, but in areas with extreme winters they have replaced open drylots with long, low, freestall barns whose curtained sidewalls can be raised or lowered according to the temperature.

The technology of haymaking also has changed, because modern dairy farmers must make such prodigious quantities of hay. In the old days, farmers mowed the hay, dried it in the field, hauled it to the barn, pitchforked it into the loft, and prayed that spontaneous combustion would not set it afire and destroy both the barn and the hay.

Farmers were pleased when they could replace loose hay with rectangular 100-pound bales, which they replaced in turn with the half-ton circular bales that have had such a dramatic impact on the rural landscape. Today, even round bales are too small, and they require too much handling, so modern dairy farmers chop their hay, pack it firmly in huge, above-ground, concrete bunker silos, cover it with sheets of white plastic, and weight down the plastic with the sidewalls of old truck tires. Enormous white mounds speckled with small black circles have replaced silos as the hallmarks of modern dairy farms throughout the United States.

Traditional cylindrical concrete silos also are much too small today, and most of them stand empty, silent sentinels of an outmoded farming system. Some farmers replaced them with tall, blue, metal Harvestores. A Harvestore is lined with glass and hermetically sealed, so hay, silage, or shelled corn come out of it just as fresh as they were when they were put in, but they must be fed quickly before they spoil.

Even Harvestores are too small to hold enough silage or haylage for a modern dairy farm, but they enable farmers to harvest their corn early, as "high-moisture corn," when the kernels are too moist to store

by conventional methods. The company that makes Harvestores also makes large, blue metal tanks that hold a million gallons of manure until time for the farmer to recycle it onto the fields for fertilizer.

Few dairy farmers in Door County have been able to develop large, new confined dairy operations, and many have stopped milking completely. The number of dairy farms in the county declined from a peak of 1,992 in 1935 to only 151 in 2002, and most of those that persist are undersized (Fig. 10). Only five milked 200 cows or more, and only one milked more than 500. The other ninety-seven percent were too small, and they were struggling to stay in business. The farmers blame their plight on the low price they get for their milk, but the sad fact of the matter is that their costs of producing milk are too high to be competitive.

There are some wonderful exceptions. Ace Schmidt has developed a specialized niche for his farm, and Dennis Schopf has demonstrated extraordinary entrepreneurial flair.

Adrian "Ace" Schmidt was born in 1941 on a dairy farm one mile south and a mile and a half west of Maplewood. He himself was a dairy

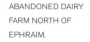

ABANDONED DAIRY
FARM NORTH OF
EPHRAIM.

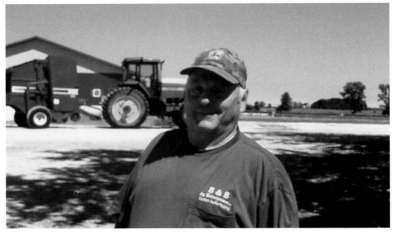

ACE SCHMIDT.

farmer and milked seventy-five cows until October 1995, when a fire destroyed the part of his barn where he housed his milk cows. He was able to rescue the cows but had to sell them, because he had no place to house them, and his back had been giving him trouble, so he was content to stop milking.

His son, Randy, who had been working out for seventeen years, wanted to come back and join him on the farm. The fire had not burned the part of the barn where Ace kept his young stock, so he kept them to raise and sell to other dairy farmers, and he and Randy decided to develop a specialized niche as custom heifer raisers for other dairy farmers.

A heifer is a young cow. She does not produce milk until she has had her first calf, when she is two years old, so for two years the farmer has to take care of her and feed her even though she is not making any money; modern dairy farmers are only too happy to pay someone else a daily fee to handle these chores for them. Ace and Randy have formed S & S Ag Enterprises to raise heifers for eleven dairy farmers whose farms are up to sixty miles away. The heifer calves are trucked to S & S when they are two to four months old, and they remain until two months before they have their first calf, when they return permanently to their home farm.

Ace started with a large barn that held 800 heifers, and he has gradually added three more. He made the front page of the *Door County Advocate* in February 2005, when he applied for a permit to expand to 4,000 head, because some people were unhappy about the amount of manure his farm would produce. In fact, he had developed an outstanding manure management program in consultation with experts in the county's Sanitation, Soil and Water Conservation, and Agricultural Extension departments, and he received his permit without difficulty.

All of the manure from all of the barns is flushed into a separation system, where the solids are removed, providing soft bedding for the cattle. That might not sound too attractive, but the solid fraction of manure is nothing more than chopped straw, and it is almost odorless. The liquid fraction flows to a two-stage system of earthen pit lagoons, which have a capacity of three million gallons each. Ace told me he was lucky, because his clay soil is so compact that he did not have to build concrete lagoons. He uses the liquid from the first lagoon to fertilize crops, and the liquid is so clean by the time it flows into the second lagoon that he can recycle it to flush out the barns.

Ace tests each of his fields to determine their nutrient requirements, and he applies manure accordingly. He needs at least 800 acres to dispose of the manure properly, but he actually farms 3,100, of

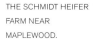

THE SCHMIDT HEIFER
FARM NEAR
MAPLEWOOD.

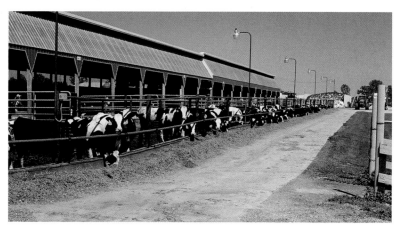

which he owns 700. He grows 1,200 acres of corn and 900 acres of alfalfa to feed the animals, 400 acres of wheat to provide roughage for their feed and straw for their bedding, and 600 acres of soybeans as a cash crop. He has enough surplus so that he can sell a complete feed ration to dairy farmers who do not produce their own.

Dennis Schopf has capitalized brilliantly on his location in a popular tourist area to make Hilltop Dairy Farm and Dairy View Country Store into one of the finest attractions in Door County. The store has a twenty-eight-foot-wide plate glass window through which visitors can watch workers milking the cows. The farm and store are a mile and a half east of Carlsville on County Highway I. Four concrete silos and two blue Harvestores tower above a clutter of other buildings. Dennis said his grandpa had twelve cows and milked them by hand. In 1950, his dad had thirty-eight cows and milked them in a three-stall milking parlor, one of the first milking parlors in the county. By 1967, he had built up to a sixty-five-cow freestall barn and a six-stall milking parlor.

Dennis was born in 1959. When he bought the farm from his father in 1996 it had 150 cows. By 2000, he had built it up to 250 cows and decided that he had to expand to 500. In 2005, he was milking 550. He said that his milking facility could handle 700, but he does not have enough barn space and would have to build another freestall barn to house them.

The cows live in long, narrow, one-story freestall barns with curtain sidewalls that can be opened or closed, depending on the weather. On either side of the barn the cows lie on soft beds of sawdust. Farmers like to keep their cows as comfortable as possible, because blood only flows to their udders to make milk when they are lying down. Feed trucks drive slowly down the wide feed alley through the center of the barn and unload a nutritious mixture of corn silage and alfalfa hay on either side, where the cows can eat it.

Three times a day the cows, in groups of twenty, walk to the milking parlor, where a worker in the central pit cleans and disinfects their

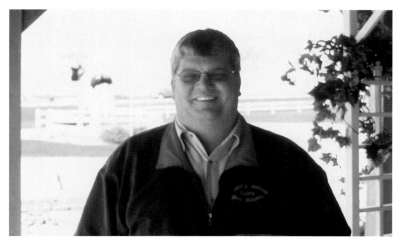

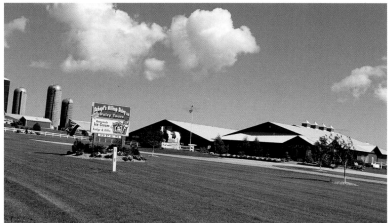

udders and attaches one of the suction cups from the milking machine to each teat. Each cow wears a computer chip in a necklace around her neck, and the computer automatically records how much milk she gives each time she is milked. The average cow produces eighty-five pounds of milk a day. Tank trucks haul the milk to a processing plant in Denmark, Wisconsin, where most of it is made into cheese, but some is hauled as far as Georgia when the demand warrants it.

Dennis grows all the feed he needs except protein concentrates on 2,000 acres of land. He owns 600 acres and rents the rest from

other farmers who have stopped farming it or from city people who have bought Door County land as an investment (Fig. 11). Dennis rents land for $30–$35 an acre, which is much less than in the southern part of the county, where the land is better and competition for it is greater. Conversely, in the northern part of the county, some owners rent their land for nothing just to keep it in agriculture, which keeps their taxes down, because agricultural land is assessed at a much lower rate than other land.

Dennis has to rent land to grow enough feed for his cows, to recycle their manure, and to use his large machines efficiently. He does custom work for other farmers on another 1,000 acres, because an expensive farm machine is not making any money for him when it is sitting in a shed, although of course it is not wearing out as fast either. The manure from the cows is flushed into a million-gallon tank at the farm and an eleven-million concrete tank at the bottom of the hill. Dennis would like to build a manure-digester that will generate all of his own electricity, but it will cost around a million dollars, and the technology is still unproven.

Dennis recycles all of the manure from his cows onto cropland according to a scientific nutrient management program. All of his soil has been mapped by a Global Positioning System (GPS), and he spreads manure according to its needs, being especially careful to maintain a proper distance from rock holes in the fields. He keeps a complete computer record of every load of manure, when and where it was spread, the temperature, and whether the day was sunny or cloudy. He hopes to use a GPS to automate manure spreading by directing the movement of each spreader.

Dennis grows 500 acres of alfalfa and 800 acres of corn to feed the cows. He mows and dries alfalfa for hay three times each summer, and in the fall he chops about half of the corn for silage. He stores both hay and silage in large concrete bunker silos and covers them with sheets of white plastic weighted down with the sidewalls of old truck

tires. The old cylindrical concrete silos are too small and too inefficient, and they stand empty.

Dennis harvests the rest of the corn as shell corn for grain to feed the cows; normally, he has more than he needs and can sell it. He stores high-moisture corn in the blue metal Harvestores. He grows 150 acres of wheat, because he needs the straw to bed calves and to add fiber to the diet of the cows. He sells the grain for cash. He also grows 500 acres of vegetables, green beans and peas, under contract with a canning company, and he grows soybeans as a flex crop on land he does not need for other crops.

When Dennis and Roxanne expanded in 2001, they realized that they needed to diversify their business by adding value to the milk they were producing, which is merely a commodity. They knew that the peninsula attracts more than two million visitors a year, so they decided to add a dairy store and gift shop and an ice cream factory. They wanted to educate their visitors, so they designed their store with the glass wall through which the visitors can watch the cows while they are being milked, twenty at a time, in the state-of-the-art milking parlor.

Anyone who is interested in modern farming, and especially any-one who is not, should visit the Dairy View Country Store, because it is

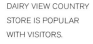

DAIRY VIEW COUNTRY STORE IS POPULAR WITH VISITORS.

a splendid opportunity to learn how a modern dairy farm produces the milk we drink. The store has a classroom where Roxanne enlightens tour groups and schoolchildren with powerpoint programs that describe the farm. In one corner is a state-of-the-art video system that gives visitors a visual tour of the barns, where they can see the cows being fed, and through the glass wall they can watch the cows while they are being milked. The walls are lined with stunning color photographs of the way in which crops are grown and harvested.

The air in the store is filtered to eliminate all barn smells. For biosecurity reasons Dennis does not allow visitors in any of the farm buildings, and even farm workers must go through four security doors to enter the ice cream plant, which is as antiseptic as an operating room in a hospital. The store sells ice cream, homemade fudge, ice cream cakes and bars, and Dennis keeps adding new products each year. It attracts 40,000 visitors a year, and some nice summer days it brings in more money than milk does. Dennis said that it is not yet self-supporting, but he is slowly building it, and he enjoys educating visitors.

Each spring he plants corn on a twenty-eight-acre field east of the farm, and when the plants are knee-high he hires a contractor who uses a GPS to create an eight-mile maze in the field by mowing the corn. Walking the maze takes around two hours. It has eighteen punchcard stations, and visitors are challenged to have their maps punched at each one. On the Saturday after Labor Day Dennis gives back to the community by allowing Sunshine House to use his maze for a fundraiser, and some of the participants even run it in their wheelchairs.

The Hilltop Dairy is a modern family farm. Dennis runs the farm, Roxanne runs the store, and his father and mother still help. His brother is in charge of all maintenance, and his sister and her husband are herdspeople for the cows. Once most family farms had a single hired man, but Dennis has to employ ten hired workers, six of whom are Hispanic, on the farm year-round, and in summer he employs fifteen part-time workers in the store.

Dennis Schopf obviously is an extraordinary person, and his farm clearly is exceptional. Most of the farms in Door County are undersized, and they cannot support a family. The census of agriculture reported that the county had 877 farms in 2002, down from a peak of 2,418 in 1935. Only 474 (fifty-four percent) of the farmers derived their entire income from their farms, and the rest had to supplement their farm income with off-farm jobs. Even many of the full-time farms needed the income of a wife who worked off the farm.

It is generally agreed that a modern family farm must sell at least $500,000 worth of farm products a year to provide an acceptable level of living for a modern American family. In 2002, only twenty-eight Door County farms sold more than $250,000 worth of farm products (and only eleven sold more than $500,000), but they produced forty-four percent of the county total, and the eleven largest alone produced a whopping thirty percent.

The other 849 are nonfarm farms. A few will be able to carve out special niches for themselves. Most must be subsidized by off-farm income. Many dairy farmers with small herds continue to milk cows because it is what they have always done. Although the farmers might be startled to hear them described this way, these small milking herds produce such meager income that they might best be described as hobbies, because one member of the farm family must find an off-farm job to produce enough income to support the family. Few hobbies demand such relentless toil, and eventually the small farmer stops milking and takes an off-farm job.

Some older people who have fully paid for their farms may be able to continue struggling along if they are willing to accept a lowering standard of living, but few young couples are able and willing to make the sacrifices necessary to keep undersized farms in business, and anyone who bequeaths such a farm to a daughter or son might properly be charged with child abuse.

The future of farming in Door County does not look propitious.

CHERRY BLOSSOMS.

Door County remains renowned for its cherry orchards, even though they are a mere shadow of what they once were. The number of cherry trees in the county has dwindled from a peak of 1,122,000 in 1959 to only about 250,000 today (Fig. 10), and its share of the nation's tart cherry crop has dropped from twenty percent in the 1940s to less than five percent in 2002. At one time, Door County was also an important apple-producing area, at least by Wisconsin standards, but most of the old apple orchards are now derelict.

Nevertheless, in late May, visitors still are lured by the benign beauty of the cherry orchards when they flower. Each blossom develops into a bright red cherry, and in picking season, from mid-July to mid-August, the highways in the county are lined with fruit stands selling fresh cherries and signs inviting visitors to pick their own.

The climate of Door County is favorable for growing cherries, because the large water bodies on either side moderate the temperature. Spring comes late, which retards tender early growth that might be killed by a late frost. The first frost in fall is also late, which gives the twigs time to ripen enough to support the next year's growth.

In 1896, Joseph Zettel, a Swiss immigrant, harvested the first commercial crop of cherries in the county on his farm north of Sturgeon Bay. It was so profitable that many other farmers began to plant orchards. Farmers with small twelve-cow dairy herds planted an acre

of cherries or two for the extra income. Many sited their orchards badly on soils too shallow to grow crops, and some used dynamite to blast holes large enough to plant the trees.

Door County had too many small, inefficient cherry growers who had high production costs, because their yields per tree were too low. In the 1950s, for example, Door County cherry growers averaged only twenty-five pounds of cherries per tree, as against fifty pounds per tree in Michigan and New York. Today, growers consider 100 pounds per tree a reasonable yield.

The largest commercial orchards were north of Sturgeon Bay and west of State Highway 42, which was an almost continuous sea of cherry orchards as late as 1960 (Fig. 12). Four companies in this area had more than 300 acres of cherries each, and the largest had more than 1,000. Some of these growers planted lines of poplar trees along the edges of their orchards, and the trees are still there, even though most of the orchards had been grubbed out by 1980, because they were poorly managed and unprofitable.

Growers plant cherry trees with twenty-by-twenty foot spacing for 108 trees per acre, or eighteen-by-twenty-foot spacing for 130. The trees are ready to harvest when they are five or six years old, and their useful life is about twenty-five years, so growers must grub out and replant five percent of their trees each year to maintain steady production. They must spray the trees four to six times a year to control insects and diseases. In the early years, they used Bordeaux Mixture (copper sulfate mixed with lime) and lead arsenate, which left residues that still persist near some old orchard areas.

Before 1960, cherries were picked by hand into black plastic pails that held five quarts or nine pounds. Good workers could pick fifty to seventy-five pails a day, and they were paid twenty cents a pail. They carried the pails to the ends of the rows and dumped them into the wooden lugs or boxes, and later into the 1,100 pound metal tanks of cold water in which they were hauled to the processing plant.

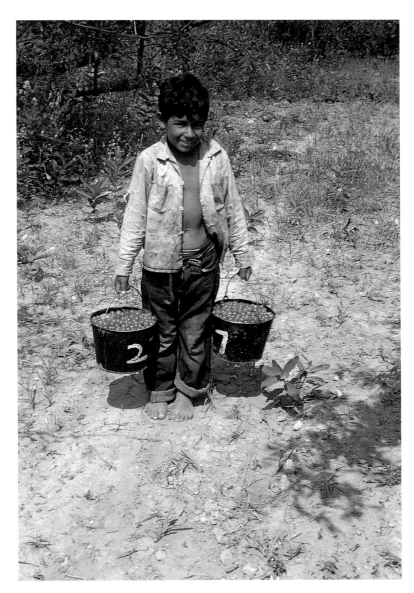

The annual invasion of the cherry pickers is a dying part of the folk-lore of Door County. Growers needed one picker per acre for the three-to-five-week harvest season, and they recruited them wherever they could find them. Until 1910, growers were able to rely on local labor,

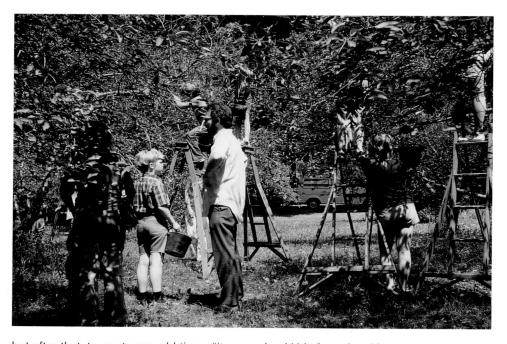

but after that, to quote one old-timer, "it was school kids from the cities, CHERRY PICKERS.

Indians from the reservation, poor whites from the Upper Peninsula of

Michigan, Jamaicans, Mexicans, German prisoners of war during World

War II, and probably others I can't even remember." One of the more

unusual groups of cherry pickers were the German prisoners of war

who were brought to Door County during the latter days of World War

II to help with the cherry harvest. Some of them maintained their local

contacts when they were returned home after the war had ended.

The growers had to provide housing for these temporary workers,

who numbered up to 10,000 in the peak years, and they had to provide

separate camps for each of the different groups to reduce conflict, but

barroom brawls were common. At one time, there were more than 150

camps, ranging from good to deplorable. Growers argued that they had

to have good camps to attract good workers and that their housing was

better than some workers had at home. They cited the fact that the

same pickers kept returning to work in the same orchards year after year

as evidence that conditions in their camps were not unacceptable, but in 1967 inspectors found that sixty-two of seventy-four worker camps were not up to specifications. Stringent regulation of worker camps encouraged growers to go out of business or shift to machine picking.

Today, the entire cherry crop is picked by machine. The picking machines have a startling variety of ingenious designs, but they all use the same general principle. The machine spreads a sheet of canvas beneath a tree and shakes it until all of the cherries fall onto the canvas, from which they roll onto a conveyor belt that carries them to the trailing tank of cold water in which they will be hauled to the processing plant. Picking machines are expensive, and small growers who cannot afford them have been forced out of the business.

Cherries have always been a risky business in Door County, because poor crop years alternate with good crop years, and the price of cherries is determined by other and much larger producing areas. For example, if a good crop in Michigan depressed the price, a grower in Door County could harvest a poor crop and still receive a price that was too low to cover the cost of producing it. Ironically, the nation's leading cherry-producing area, which is on the Grand Traverse penin-

AN OLD SIGN FOR
HISPANIC MIGRANT
WORKERS SOUTH
OF STURGEON BAY.

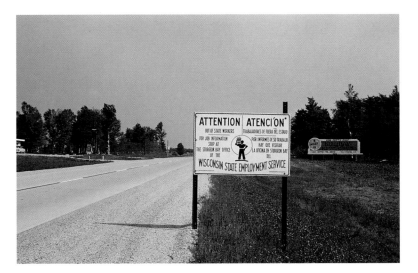

CHERRY PICKING
MACHINES.

sula of northwestern Michigan, was started by growers who moved
there from Door County in 1920.

The cherry business in Door County has been whipsawed by regu-
lar cycles of overproduction. Eager growers have planted more trees
when prices have been good, but then, when the new trees have
begun to bear, the fruit has glutted the market and depressed prices
below the cost of producing it. In Door County, for example, two-thirds

of the 1987 cherry crop, 9.5 of fourteen million pounds, was allowed to fall to the ground unharvested, because there was no market for it.

In 1997, the nation's cherry growers agreed to a Federal Marketing Order that would maintain a steady supply of cherries to the market but would avoid glutting it and thus ensure a reasonable price for growers. The order requires growers to set aside and store in a national pool the surplus they have produced in good years and to sell from the pool in poor years. The year 2005 was a good year, and about thirty-five percent of the crop was held back. This marketing order has brought welcome stability to cherry producers.

In the peak years, Door County had around 600 cherry growers. By 2002, the number of growers had shrunk to only sixty-five, and only five or six were producing at a truly commercial scale. The rest produced only enough to supply their roadside stands and pick-your-own operations. Most cherry growers also have a modest acreage of apples, pears, plums, and other fruit. Door County had 3,200 acres of apple orchards in 1945 but only 700 acres in 2002. Most apples are grown by fruit stand owners, because their customers expect them, but the cost of producing apples is so great that the growers probably are losing money on them.

ABANDONED
ORCHARD.

Dale Seaquist, whose farm is two miles north of Sister Bay, played a major role in convincing growers to vote for the marketing order. Dale is the largest cherry grower in Door County. He has 90,000 cherry trees in fifty-three blocks scattered all over the county and plants 10,000 new trees each year as replacements. He has fifteen tractors, a dozen trucks, and two harvesting machines. Dale himself built the first cherry harvester in the county, sort of like a giant upside-down umbrella, more than forty years ago.

DALE SEAQUIST.

SEAQUIST ORCHARDS FARM MARKET NEAR EGG HARBOR.

Dale was born in 1933 on the farm that has been in his family for 140 years. In 1906, his grandpa heard about the new cherry orchards, and he made a three-day trip to Sturgeon Bay to buy 700 seedlings. They were still milking cows when Dale took over the farm, but he said that he figured cherries were an easier way to go broke, and he has specialized in growing cherries. At first, he sold fresh cherries out of a shed, but twenty years ago he and his wife Kristen opened Seaquist Orchards Farm Market, which was recognized as an Outstanding Farm Market of the Year in 2005 by the North American Farmers' Direct Marketing Association.

The entire Seaquist family is involved in the operation, and each one does what he or she likes best. Dale and son Zach handle equipment maintenance and all orchard activities. Kristen manages the store, which is a showplace. Son Jim manages the processing plant, and his wife, Robin, manages the farm business office. The processing plant is one mile east of Egg Harbor. It processes all of the Seaquist cherries, as well as cherries from fifteen other growers, and produces ten million pounds of frozen cherries a year in fifteen- and thirty-pound containers.

The cherry business, not just locally but nationally, needs to rise above the level of sponsoring cherry pit spitting contests at the Door County Fair and do a better job of product development and marketing. Fifteen- and thirty-pound containers may be fine for bakeries and institutions, but they are a bit large for most homes. The cherry business is still producing a commodity for others to process, but it is neither producing a value-added product that visitors to Door County feel compelled to take home as a souvenir nor is it developing convenient, ready-to-use, value-added products that will appeal to contemporary consumers who are reluctant to spend time in their kitchens.

When was the last time that you baked a cherry pie from scratch?

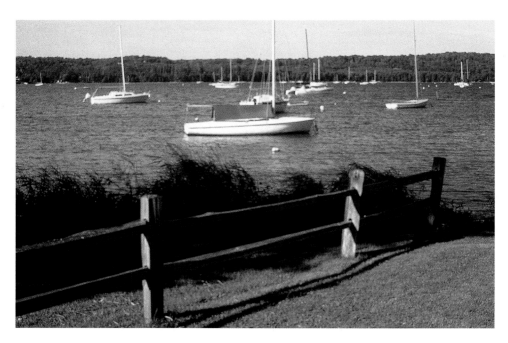

SAILBOATS IN EAGLE HARBOR AT EPHRAIM.

For more than a century people have been seeking out Door County for their summer vacations, and in recent years many erstwhile summer people have retired to second homes in the county, which means many different things to different visitors. Craggy limestone bluffs, scenic vistas, rocky shores, sandy beaches. Clean air and gentle breezes from the lake or bay that moderate summer temperatures. Waters that teem with fish. Shipwrecks for scuba divers to explore. Sailboats, canoes, kayaks. Flowering orchards in May, summer wildflowers, fall colors. Picturesque villages nestled at the heads of snug little harbors. State parks and private campgrounds. Hiking and birdwatching. Golf courses. Peaceful rural roads almost devoid of traffic other than bicycles and joggers. Adult education classes. Music and theater, art galleries and craft shops, painters, potters, sculptors, weavers, and wood carvers, the list seems to go on and on and on . . .

Tourism actually developed fairly slowly in Door County, because it was so inaccessible. Door was the last county in Wisconsin to have a railroad. Before 1892, the closest station was in Menominee, on the western side of Green Bay, from which visitors could take a boat across the bay in summer or a sleigh across the ice in winter. Most visitors from Chicago and Milwaukee preferred to take the steamboat on Lake Michigan, which was a twenty-four hour trip.

The weekly steamboat stopped at each village. Its arrival was a major event. It sounded a long blast on its whistle when it entered the harbor, and the villagers flocked down to the dock to watch the summer visitors disembark with their hulking steamer trunks and to escort them to the homes where they would be staying.

Most summer visitors continued to travel to Door County by boat even after the Ahnapee and Western (A & W) Railroad was completed in 1892, because the A & W was a short branch line that was hard to take seriously. The railroad main line ran from the car-ferry terminal at Kewaunee to the city of Green Bay, while the A & W was merely a spur that branched off at Casco Junction for Ahnapee (which changed its name to Algoma in 1899) and thence to Sturgeon Bay (Fig. 13). Perhaps as a harbinger of things to come, trains had to run backwards on the line until the railroad built a turntable in Sturgeon Bay in 1898.

The A & W was built with lightweight rails that could not handle heavy loads, and it bought secondhand, lightweight locomotives that had trouble coping with Wisconsin winters. Engine failures and derailments were common, and passenger trains sometimes were stalled behind overloaded freight trains struggling to climb steep grades. Heavy snow and ice storms frequently closed the line for days, because the underpowered little locomotives simply could not plow their way through snowdrifts in deep cuts. One marsh was so impassible for locomotives in spring that workers had to uncouple the cars and push them across it to a locomotive waiting on the other side.

The maximum safe speed on the line was thirty miles an hour and only ten on the swing bridge across the bay at Sturgeon Bay. A train had to wait for twenty minutes if the bridge had to be opened and closed to let a ship pass through. The bridge seemed to be a magnet for ships, which smashed into it regularly, and it seemed to be under repair most of the time. Passenger service was undependable and not particularly pleasant, because the A & W kept its original, secondhand passenger cars in service for the entire life of the line.

70

By 1920, the A & W was already losing business to bus and trucking companies, but it gamely started direct sleeping car service to and from Chicago on weekends. The trip took fifteen hours, and then passengers had to take buses to the resorts on the peninsula. Small wonder that most summer visitors preferred to travel by boat directly to the village where they were going to stay. The A & W discontinued passenger service in 1937, and the line was abandoned after the bridge in Sturgeon Bay was condemned as unsafe in 1968. After the tracks were taken up, the state converted the abandoned right-of-way from Sturgeon Bay to Algoma into the Ahnapee State Trail for hiking, biking, and snowmobiling.

The long trip to Door County, whether by boat or by train, took such a large chunk out of a two-week vacation that most of the summer visitors in the early days were people with plenty of time or plenty of money. The county attracted affluent professional people from Chicago and Milwaukee, who had plenty of money, and faculty members from Northwestern University and the Universities of Wisconsin, Chicago, Illinois, and Iowa, who had long summer vacations (Fig. 14).

AHNAPEE STATE TRAIL
IN MAPLEWOOD.

As but one example of the kinds of money that came to Door County, in 1984 a federal tax court judge ruled that Ben W. Heineman, chairman of Northwest Industries, could claim his $250,000 one-room office, which hangs over a cliff near Ellison Bay, as a legitimate business expense, because he reviewed his company's long-range plans at his secluded summer home, and he could think better when the distractions of city life and Chicago's blistering summer heat were left behind.

Those who came to Door County were white-collar people who sought sanctuary, not excitement. They knew how to entertain themselves and wanted only a haven of peace and quiet where they could read, meditate, and commune with nature. The leisurely pace of life was not dominated by the clock or by the calendar, and people did things when they got around to doing them. Electricity and telephone service were late and erratic, and some people scorned them as intrusions on their peace and quiet. As late as 1950, some villages had only a single pay phone or a phone in the village store.

Its early inaccessibility thus gave Door County a distinctive style and cachet that it has never lost. It has had little commercial recreational activity, such as theme parks, amusement parks, and garish attractions. Such establishments have been unsuccessful, because the kinds of people who come to the county do not patronize them, and the kinds of people who patronize them do not come to the county.

By the 1930s, buses and automobiles had begun to replace boats and trains for the trip to Door County. The drive from Chicago took two days, with an overnight stop in Sheboygan, and it was an adventure, because the roads were unpaved, unmarked, and unfenced. Getting lost on unmarked roads was easy, breakdowns were the norm, and once or twice on every trip the driver had to get out, jack up the car, and change a flat tire. Farm animals roamed freely on the unfenced roads, and hitting a stray hen or dog was not unusual.

Since 1950, better roads and better cars have made Door County much more accessible, although traffic backups at the narrow two-lane

bridge in downtown Sturgeon Bay were legendary before the Bayview bridge and the bypass were built. The county is now an easy weekend trip from Chicago or Milwaukee, and the number of visitors has increased enormously. A surprisingly large share of its development has occurred in the last twenty or thirty years.

Development has been concentrated along the two main highways, which are seriously congested, but inland roads are well paved, well maintained, and virtually deserted even at the height of the summer season. They are delightful for bikers and joggers and for peaceful rural drives. The Chamber of Commerce has published a splendid "Backroad Bicycle Route" map, but it is wonderful fun to explore them on your own.

The distinctiveness of Door County was demonstrated forcibly in March 1969. When *National Geographic Magazine* published an article on the county that attracted many new visitors. Some of them were delighted and have continued to return year after year, but others were

quite disappointed. The peace and quiet of Door County did not appeal to people who hitherto had frequented frenetic commercial recreational areas, such as the Wisconsin Dells or the "speed and blood" hunting, fishing, powerboating, and snowmobiling areas north of Rhinelander, and they complained, "There's nothing to do in Door County." Few have been back since, and no one is especially unhappy.

Door County attracts many visitors, because of its fame as a center of the visual and performing arts. The academic summer residents have always supported the arts. An art professor from Chicago opened the first summer arts school in the county near Baileys Harbor in 1922, but the local arts community did not really begin to boom until the 1970s. Many artists had visited the county to enjoy its natural beauty. They realized that it was such a splendid place to do creative work, especially for people whose work was not tied to a specific location, that they returned to become permanent residents and opened their own studios and galleries, which attract many visitors.

74

The Peninsula Arts and Humanities Alliance publishes an annual Door County Arts map that shows the art galleries and studios in the county. The 1985 edition showed only fifty, but the 2005 edition showed ninety-four (Fig. 15). They were scattered through the county north of Sturgeon Bay, with the greatest concentration between Juddville and Sister Bay.

Door County in summer is a cultural magnet. The Peninsula Players, the American Folklore Theater, Door Shakespeare, the Third Avenue Playhouse, and other groups stage regular live theater. The Peninsula Music Festival in the Door Community Auditorium in Fish Creek is a highlight of the summer, students flock to the summer music camp at Birch Creek, and many restaurants schedule live music. The Clearing, Jens Jensen's famed folk school north of Ellison Bay, and Björklunden, south of Baileys Harbor, have superb adult education programs.

The villages of Door County do their best to capitalize on visitors by taking turns staging weekend festivals, in winter as well as in summer. Any excuse is good enough to justify a festival, and every village hosts at least one during the summer, with parades, marching bands, coronation of local worthies, costume contests, bake sales, craft sales, silent auctions, and fireworks in the evening.

One facet of Door County summer life that belongs almost exclusively to year-round residents is sandlot baseball, because visitors seem largely unaware of it. Eight villages in the Door County League are proud of teams of relatives and neighbors that play each other on Sunday afternoons, when visitors are driving home or getting settled for the week. The admission charge is modest, and spectators sit on weatherbeaten wooden bleachers and in or on their cars and pickup trucks parked next to the foul line fences.

The summer visitors who have come to Door County have had to have a place to lay their heads, and the county has had a wide variety of accommodations to house them. In the early days, local people rented rooms in their homes to visitors who took their meals with the

SAND LOT BASEBALL
IN SISTER BAY.

family, and as the number of visitors increased the locals began build-
ing simple cabins for summer rental. In time, the visitors began to buy
attractive properties on which to build their own summer cottages. As
early as 1921, the *Door County Advocate* reported that outsiders had
bought the most desirable part of the county's shoreline, and by 1980
waterfront property was selling for more than $1,000 per front foot.

Summer cottages have become a significant component of the
county's housing stock. More than half of the housing units north of
Carlsville and Jacksonport were unoccupied on April 1, 2000, when the
latest census of population and housing was taken (Fig. 16). Many
summer cottages began life as simple rustic cabins with few amenities,
such as running water and electricity, but over time their owners have
modernized and winterized them into homes that are indistinguishable
from urban residences. Many probably are used today as retirement
homes, but no one knows how many, because anyone who can afford a
summer home in Door County probably can also afford a winter home
in the Sunbelt, where they were wise enough to be in April when the
census was taken. Some families have been coming to Door County for
three, four, even five generations, and the summer cottage/retirement

home in the county is a splendid place for reunions of farflung families.

Many of the longtime "summer resorters," as they are known locally, have developed close personal friendships with local people, upon whom they depend for construction, maintenance, and other services. The initital contacts were not always cordial, because the summer people had to learn to adapt their brusque city ways to the more relaxed Door County lifestyle, but in time they have come to appreciate and even to emulate it. Condominium owners, renters, and weekend visitors rarely develop such ties, and both sides are the poorer therefor.

Summer cottages line most of the shores of Door County. In places they are crowded as close together as houses on city streets, and they effectively cordon off the water, but they are wellnigh invisible. For mile after mile the roads along the shoreline pass through densely wooded areas, and at regular intervals lanes disappear mysteriously back into the woods, but only rarely do you glimpse any buildings, much less the water beyond them.

Shoreline property has become so expensive (and there rarely is any for sale anyhow) that people have begun to build new summer cottages all over the county at inland sites that seem bizarre, but remem-

SHORELINE COTTAGES.

ber that every summer home, no matter how incongruous its location and no matter how humble and unprepossessing its appearance, is someone's precious piece of paradise. At the other extreme, too many insensitive people have begun to build obscenely opulent mansions that might not be out of place in an affluent suburb but are totally inappropriate for Door County. The quiet afternoon drink and good conversation on the terrace has been replaced by the raucous cocktail party.

The first hotels in the county were crude affairs, no more than rooms for rent above saloons, and they were hardly suitable for family vacations. There is disagreement about the site and date of the first hotel that was intended mainly for summer visitors, but by 1917 such hotels were common (Fig. 17). Few of them had running water or electricity, and their principal attraction was their long front porches with lines of comfortable rocking chairs where patrons could sit and chat, sit and think, or just sit.

Over the years, the old hotels have been modernized or demolished, and a number of new motels have been built. A seasonal resort area, such as Door County, is not an attractive location for major hotel and motel chains, so most lodging facilities in the county are small, fam-

THE ANDERSON
HOTEL IN EPHRAIM.

ily-owned operations. Many require a minimum stay of two or three nights. Resorts and lodges are larger, with central hotels and outlying cabins. They have elaborate suites of activities to entertain their guests and expect them to stay longer, perhaps for a week or more.

Door County also has a range of public and private campgrounds (Fig. 18). The county has six state parks, more than any other county in the United States, and three have camping areas. Peninsula State Park, which has 469 campsites, is one of the oldest, largest, busiest, and most complete parks in the state system. Potawatomi State Park has 123 campsites on a former military preserve. Newport State Park has sixteen wilderness campsites that only backpackers can reach and use. The state parks also have a rich variety of other facilities. The owners of second homes complain bitterly that the State of Wisconsin forces them to pay out-of-state fees to use the parks, even though they are paying outrageously high property taxes on their homes.

The newest form of accommodation for summer visitors to Door County is condominiums. The county has had a flurry of condominium

construction in recent decades, and in 2005 it had a total of 205, with 5,550 individual units (Fig. 19). Most of the county's condominiums are on the bay side, where developers have been paying premium prices for prize parcels of real estate and building luxury units that they are selling for up to a million and even more. Many of the buyers are aging baby-boom empty-nesters who want to escape the headaches of maintaining a house, but some are buying solely for investment purposes and rent their units to others.

People on vacation need to sleep. They also need to eat, and they seem to feel a need to spend money on things they would be smart enough not to buy if they were at home. Door County obliges them with a throng of eating places, gift shops, and other businesses and services that are entirely too numerous even to begin to try to mention. These establishments are necessary to serve visitors, and they are also essential to the economy of the county, because tourism employs about half of its working poopulation, which is both good and bad.

Serving visitors provides jobs that retain in the county young people, who might otherwise have had to seek them elsewhere, and that attract new people. A well-known example of a person who has started a succesful service business is Dorthea Johnson, who combines a shrewd head for business with a keen sense of humor. She and her husband lived in Toledo, Ohio, but both were born in Door County and wanted to move back. When she visited her mother, she realized that the county had no garbage service, so she started one in 1964. She picked its name because her father had been an auctioneer, and she had been hearing "Going, going, gone" all her life. Many residents of the county now trust Going Garbage, whose motto is "Satisfaction guaranteed or double your garbage back."

On the less positive side, most of the businesses and services that cater to visitors in Door County are small sole proprietorships, and they have a difficult time, because their success depends on the whims and fancies of tourists. Each year some go broke, and next summer the

HOME BUILDER IN
STURGEON BAY.

name of a new hopeful is on the premises. Door County is a tough
place to do business.

The owners of tourist-oriented businesses must make most of their
twelve-month income in only fourteen hectic weeks between Memorial
Day and Labor Day, and they are challenged to find people willing to
work for only three months of the year. Many rely heavily on students
but have to find housing for them, because students cannot afford the
high housing prices charged in a summer resort area.

Resort interests have demanded laws prohibiting schools and col-
leges in Wisconsin from starting fall classes before Labor Day, because
they do not want to lose their workers just before one of their busiest
weekends of the summer. *The Door County Advocate* supported them
with an editorial lambasting "The Annual Kidnapping" of the county's
labor force by schools and colleges that started earlier.

Tourism will continue to be the mainstay of the Door County econ-
omy, but continuing growth will create serious problems. The most pop-
ular tourist area, along State Highway 42 from Egg Harbor north to
Sister Bay, is already coalescing into a unique new mini-city: a continu-
ous, built-up strip fifteen miles long. Outrageously high and constantly

rising property taxes are forcing local people and older people on fixed incomes to wonder whether they can continue to live in the county, and the lack of affordable housing discourages seasonal workers and young couples with families. Underneath it all, the Niagara limestone aggravates water pollution and complicates wastewater disposal.

HIGHWAYSIDE STRIP DEVELOPMENT SOUTH OF SISTER BAY.

Door County must grapple with the paradox of paradise: its beautiful natural environment attracts hordes of visitors, but each new development to serve them inevitably intrudes on that environment and generates controversy. Some unscrupulous developers are scoundrels who have consistently pushed the envelope, but some critics are gangplankers who want to maintain the area precisely as it was when they first laid eyes on it, and they vigorously oppose any and all change. It is much too glib, however, to assume that local people favor development and that newcomers oppose it, or vice versa, because individuals line up on opposite sides of particular issues.

Door County is a Republican stronghold, and many residents viscerally dislike the idea of anything, such as planning, that smacks of

government. County, township, and village board meetings have become acrimonious and personal when development and planning were on the agenda. It was a pleasant surprise, therefore, when the *Door County Advocate* reported, on July 29, 1998, that the county board's unanimous endorsement of a comprehensive county land-use plan, which could have resulted in their impeachment only a few years ago, had been hailed as a long-needed accomplishment by environmentalists and developers alike.

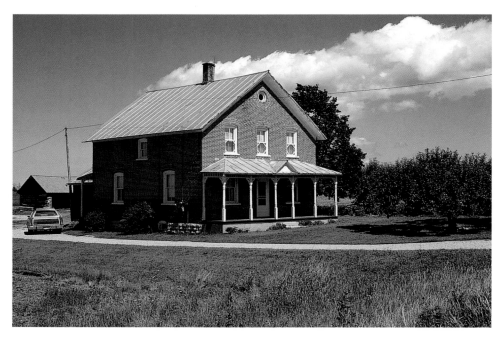

A TRADITIONAL BELGIAN BRICK HOUSE.

Recently, one of my friends told me that he had visited Door County. "I can't remember the name of the place where we stayed," he said, "but it's the one with the ice cream parlor." I knew immediately that he was referring to Wilson's in Ephraim, but his remark made me realize that we often identify places by their landmarks rather than by the names that people happen to have assigned to them, so in the rest of this book I describe some of the landmarks you will see as you drive northward in Door County, first in the Belgian area, then in Sturgeon Bay and on the bay side (Chapter VIII), and finally on the quiet lake side (Chapter IX).

Southwestern Door County and adjacent parts of Kewaunee and Brown counties have the largest rural settlement of Belgians in the United States (Fig. 20). The Belgian area, which has many distinctive buildings, is the best-known ethnic area in Door County. The ancestry of most of the county is predominantly German, but the northern part has many people of Norwegian and Swedish ancestry, and the eastern side has a few small Polish clusters. At one time, Washington Island was home to the largest group of Icelanders in Wisconsin, but they have all moved to Racine (Fig. 21).

The Belgians in Door County are the descendants of immigrants who came here between 1853 and 1857 from the French-speaking

Walloon area of southern Belgium. Namur, west of Brussels on State Highway 57 (Fig. 1), is the southern tip of the Belgian-American Historic District, which was designated a National Historic Landmark Area in 1990. The roadside mailboxes have only a small number of surnames, such as Baudhuin, Massart, and Jeanquart.

Visitors driving through the Belgian area have to fight extremely heavy traffic on a treacherously narrow, two-lane highway, which was

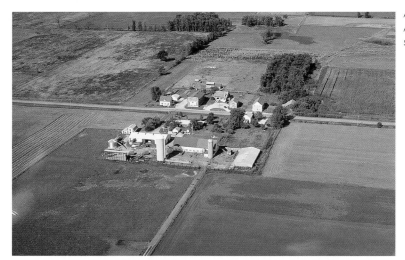

AERIAL VIEW OF A CLUSTER OF FARM-STEADS.

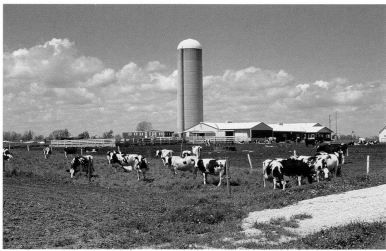

DAIRY COWS AND A SIGNATURE SILO.

scheduled to have four, long-overdue lanes by 2008. If they have time to look away from the road they might be excused for thinking that this is just another unexceptional Wisconsin dairy area. The pleasant rolling countryside is dotted with well-kept farmsteads on small dairy farms of eighty to 120 acres, and there is almost no roadside development.

Most farmsteads are dominated by massive, two-level dairy barns. The ground floor, of solid masonry or cinderblock, is lined with windows that admit light and air to the stanchions on the lower level, where the cows are tied and milked. The wooded upper level is an enormous loft for storing hay, and at one end towers a large, cylindrical, concrete silo for storing chopped corn. The combination of a loft for storing alfalfa hay and a silo for storing corn silage was an extraordinarily efficient structure for feed management on a small forty-cow dairy farm, but the old barns are not suitable for modern dairy operations, and most of them have been abandoned or are in sad disrepair.

Visitors who have time to take a closer look at the Belgian area will see some types of buildings that are unique to the area. The most distinctive and characteristic buildings are modest rectangular red brick houses of two stories and an attic. The principal entry door in the gable

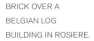
BRICK OVER A
BELGIAN LOG
BUILDING IN ROSIERE.

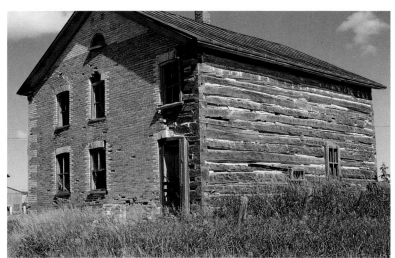

A TRADITIONAL
BELGIAN BRICK
HOUSE WITH A SIDE
ENTRANCE BEFORE
(TOP) AND AFTER
(BOTTOM) SIDING,.

end facing the highway has two windows on either side, and two or three windows on the second story. The real diagnostic trait of these houses is a small round or semicircular attic window in the eaves at the gable end of the house. A few houses in the Belgian area are built of limestone quarried on the site, but most of the older houses are red brick.

The first Belgian arrivals built log houses, because that was the custom of the country to which they had migrated, but they were not

skilled in log construction and used contorted cedar logs. The great fire of October 8, 1871 destroyed most of these houses. After the fire, people placed brick veneer over the few log houses that had escaped. They continued to build in log, using fire-scarred logs they had salvaged, but they veneered all of their new log houses with brick.

Some people think that the Belgians used brick veneer to make their houses more resistant to fire and to weather, but more probably the idea of brick houses was part of the cultural baggage they brought with them from Belgium. Log buildings had to be veneered, because they simply looked too primitive. Recent generations have continued this pattern by placing more modern types of siding over some of the old brick houses, which they consider too old-fashioned.

The Belgians also brought with them the European pattern of having separate outbuildings for each farm activity and for each type of farm animal instead of building a single, large, multifunctional farm structure. As a consequence, the early Belgian farmsteads had many small, specialized log structures, such as threshing barns, hay sheds, granaries, smokehouses, woodsheds, stables, cowsheds, pig sties, chicken houses, sheepsheds, and the like. Some of these buildings were connected one

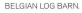
BELGIAN LOG BARN.

to another, while others stood alone. After 1900, prosperous farmers began to replace the clutter of old log buildings with standard Wisconsin two-level dairy barns, but many of the small, old, weatherbeaten log farm outbuildings remain part of the rural landscape.

The Belgian area once had two other distinctive types of structures, bake ovens and roadside chapels, that have largely disappeared today, although a few still remain. The large, separate bake oven was another idea that the Belgians brought with them from Europe. It was a small appendage, four feet high by six feet long by seven feet wide, that was built onto the back of the detached summer kitchen behind the farmhouse. This appendage contained an oval oven large enough to bake twenty-four loaves of bread at a time. Once nearly every farm had to have one, but now most have been demolished, along with the summer kitchen.

The roadside chapel was a seven-by-nine-foot frame structure nine feet high that was sometimes mistaken for a toolshed or a misplaced privy, although toolsheds and privies rarely have crosses on top of them. The Belgian people were devout Roman Catholics, and they built these chapels of ease for daily devotions by families that lived too far from a church. Many were built in gratitude for prayers answered or strokes of good luck, and some were believed to have miraculous healing powers. They were built close to the highway for the convenience of travelers, and many were removed when roads were widened.

The Belgian area was devastated by the great fire of 1871, which burned over northern Kewaunee County and the southern half of Door County (Fig. 22). The Tornado roadside park on State Highway 57, three and a half miles north of Brussels, memorializes the site of the village of Williamsonville, which the fire completely destroyed. The village had a population of seventy-seven people, and sixty-one of them suffered a horrible death from burns or suffocation.

That same night a similar fire wiped out a vast forest area on the western side of Green Bay north and south of Peshtigo, where 1,000

BELGIAN ROADSIDE
SHRINE.

people were killed, and fires burned 2.5 million acres in lower Michigan. Few people know about these fires, because they were overshadowed by the great fire that burned Chicago that same night, even though the loss of life at Peshtigo was far greater.

The winter of 1870–1871 in Door County had almost no snow, and the summer of 1871 was the second driest that has ever been recorded. Just a few light showers fell all summer, and even the swamps were dry. The summer seemed hot, because it was so dry, but in fact temperatures were close to normal. All summer long small fires kept burning in the inflammable slash that lumbermen had left in the woods and bogs, and fires kept smoldering in the leaf mold beneath the trees. The air was heavy with smoke and haze.

On October 8 a front advancing across northern Wisconsin and the Upper Peninsula of Michigan brought dry air from the southwest. The winds fanned small fires, small fires joined to form larger fires, and larger fires merged into a major conflagration. The heat was so great

that it created a fierce updraft, which sucked in winds at speeds of eighty to ninety miles an hour that spawned a veritable tornado of fire. The roaring winds hurled flaming debris and burning coals far and wide, and they set the entire village of Williamsonville on fire.

Williamsonville had a shingle mill, a boarding house for the workers, a store, eight houses, and various other buildings in a ten-acre clearing where the people assumed they were safe from forest fires, but they kept buckets and tubs full of water, just in case, and they kept blankets soaking wet as tools to fight fires if they needed them. When all of the buildings began to go up in flames, sixty people wrapped themselves in wet blankets and ran out into an open field; fifty-eight of them suffocated or died a fiery death. Seven people hid in the village well, but only five of them survived.

Williamsonville had the most traumatic experience, and it is fitting that the memorial should be where it once stood, but the entire southern half of Door County lost human and animal lives, homes, barns, and entire villages. Fifty-six houses were burned in Brussels, and in Rosiere only five of 180 houses were left standing after the fire, which mercifully was quenched by rain before it reached Sturgeon Bay.

Tours of the landmarks of northern Door County begin at the city of Sturgeon Bay, which is the county seat and the principal commercial center of the county (Fig. 1). The narrow streets and especially the two-lane bridge in Sturgeon Bay were notorious traffic bottlenecks until the bypass and the Bayview bridge were opened in 1978, but since then the city has virtually disappeared from tourist view, and it has been struggling to tap back into the business that it has lost.

Third Avenue, the principal business street, which runs parallel to the waterfront, has been renovated to give it a turn-of-the-twentieth-century air. An enormous, blue gantry crane looms above the largest shipyards on the Great Lakes, which are just north of downtown on Third Avenue and west on Florida Street. Small metalworking companies have plants in the light industrial area along the bypass.

The focus of Sturgeon Bay is the Michigan Street bridge, a unique counterweighted bascule structure that connects downtown with the south bay community of Sawyer, which was an independent entity until the city annexed it in 1891. The movable spans of the Michigan Street bridge, which was built in 1931, are a historically significant piece of machinery, but an engineering survey in 1995 concluded that the bridge was functionally obsolete. It was patched up enough to last until 2006, but in 2005 the Wisconsin Department of Transportation set off a political firestorm by announcing that it would have to be closed

eight months for a major overhaul that would extend its life for another twenty-five years.

Downtown merchants were appalled by the prospect of being marooned in a cul-de-sac for nearly a year, and they demanded that the state should build a new bridge before it closed the old one for repairs, which does seem to make sense to anyone but a bureaucrat. They launched a massive lobbying effort, and to buttress their case the city

THE DOOR COUNTY
MARITIME MUSEUM
IN STURGEON BAY.

THE DOOR COUNTY
HISTORICAL SOCIETY
IN STURGEON BAY.

94

council conducted a tendentious "referendum" with heavily slanted questions. It worked. On July 14, 2005, Governor Jim Doyle of Wisconsin announced that the state would built a new bridge two blocks south of the old bridge before it began to rehabilitate the old bridge.

The outstanding Door County Maritime Museum, which is just east of the south end of the Michigan Street bridge, has been supported generously by local shipbuilders. It has a superb collection of models of ships that have been built locally, a complete mockup of a pilothouse on a Great Lakes ore boat, and exhibits chronicling the history of shipbuilding in Sturgeon Bay. The Door County Historical Museum, one block north of the east end of Third Avenue, is also an excellent museum, with exhibits featuring small town and rural life.

Four miles north of the Bayview bridge a stoplight marks the intersection of State Highway 42, which goes up the bay side of the peninsula, and State Highway 57, which forks eastward along the lake side (Fig. 1). Inside this fork north of Highway 57 is the Pete and Val Polich farmstead, which has two concrete silos, two tall, blue metal silos, one short, blue metal silo, and a massive, squat round blue metal tank. This tank holds 600,000 gallons of manure until Pete is ready to recycle it onto his 350 acres of corn, alfalfa, soybeans, and wheat.

PETE AND VAL
POLICH'S FARM.

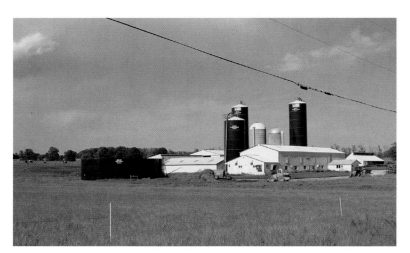

Pete grows these crops to feed cattle. Until 2003 he was milking eighty-five dairy cows, but the price of milk was so low that he decided to stop milking, take a job in town, and feed 125 dairy steers for beef. He buys three-month-old calves from dairy farmers and sells them when they are eighteen months old and weigh 1,500 pounds. He can do all of the necessary work on his farm evenings and weekends.

John Alaers, who owned a crossroads tavern nine miles north of Sturgeon Bay, was annoyed because the crossroads did not have a name, and he could not tell people where to find it. He gave its location as Alaersville when he had posters printed for a dance. Residents Karl Goll, Karl Krauel, Karl Krueger, Karl Schultz, Karl Schuster, and Karl Wolzien, both senior and junior, immediately told him that a German hamlet should not be named for a Belgian. Alaers readily agreed and said he would name it after them, but he insisted that "the name of Carlsville should be spelled with a C, because we are in America."

The Door Peninsula Winery in Carlsville, which opened its doors in 1967 in the former schoolhouse, makes twenty-five different kinds of grape and fruit wines. The Hilltop Dairy Farm and Dairy View Country Store 1.4 miles east of Carlsville gives visitors an unparalleled opportu-

THE DOOR PENINSULA WINERY IN CARLSVILLE.

nity for learning how a modern dairy farm works by watching through a plate-glass wall as workers milk cows in a milking parlor.

Schartner's Farm Market is 2.4 miles north of Carlsville. Dave Schartner was born in 1961 and grew up on his father's forty-five-cow dairy farm. He decided that he didn't want to milk cows for the rest of his life, so he started the market in 1986 and grows what he can sell fresh there. He has thirty acres of cherries, fifteen acres of pumpkins ("I'd rather have enough than run short"), ten acres of apples, and small acreages of strawberries, raspberries, pears, and plums. Dave served four one-year terms as the president of Wisconsin Cherry Growers, a trade association of sixty-five members, but he said that was enough, although he is content to continue as spokesman.

The western side of the road cut 0.3 miles north of Schartner's Farm Market has a fine example of the way that limestone rocks can be dissolved by groundwater.

State Highway 42 plunges into Egg Harbor through a trench cut into the Niagara Escarpment. At the foot of the escarpment is the Chief Oshkosh trading post. Roy J. Oshkosh was the hereditary chief of the Menominee nation and the last, because he had no children. He was

THE CHIEF OSHKOSH TRADING POST IN EGG HARBOR.

born on the reservation in 1898, went to the Carlisle Indian School in Pennsylvania, where he became an electrical engineer, and worked in the Sturgeon Bay shipyards during World War II.

While he was living in Sturgeon Bay, Roy searched for a traditional Menominee tribal campground about which his grandmother had told him. When he found it, he bought the land and built a trading post and amphitheater, where he held powwows and staged tribal dances. After his death, Coleen John, a member of the Oneida nation, bought the trading post, which still specializes in native American arts.

Egg Harbor's landmark is the cupola house that Levi Thorp built in 1871. Levi had struck it rich in the California goldfields. He returned home, bought the largest farm in the county, erected a dock for shipping cordwood and cedar, and built a home befitting his stature as a successful merchant to replace the log cabin in which he and his family had lived since his return. He bought the finest pine wood on the Upper Peninsula of Michigan and hauled it across the ice on Green Bay in winter. The cupola commands splendid views and acts as a flue, allowing warm air to leave and drawing in cool air to replace it on the lower floors. In 1982, the cupola house was remodeled into antique shops, and it is on the National Register of Historic Places.

Birch Creek is a highly regarded summer music camp that was founded in 1976 in a modest barn three miles east of Egg Harbor on County Highway E. It attracts 200 talented students aged twelve to nineteen and a faculty of eighty professional musicians for four intensive two-week sessions (symphony, percussion and steel band, big band jazz twice) each summer. The educational program is strongly performance-oriented, and each student plays in at least eight public concerts during the two-week camp.

Peninsula Players Road is 3.4 miles north of the curve in Egg Harbor. The Peninsula Players Theatre, the oldest professional resident summer stock theater company in the United States, is 0.6 miles west on the shore of Green Bay. This theater in a garden was founded in

1935 by Richard Fisher and his sister, Caroline Fisher Rathbone, whose charm, drive, flair, and dedication to the theater was legendary. Caroline was the soul of the Players.

The Fishers bought a former boys' camp and converted it into an open-air theater under a flapping tarp. In 1957, the company built an all-weather pavilion with roll-up canvas sides, but it could still get uncomfortably chill and damp on cool summer evenings. In 2005, the company announced plans to rebuild the theater and pavilion, to increase seating from 550 to 580, and to renovate the infrastructure and amenities. Normally, the Players stage five three-week productions each summer from late June to mid-October.

Just east of State Highway 42 on Peninsula Players Road is the Edgewood Orchard Gallery, one of the most elegant on the peninsula. In 1969, when her father died, Anne Emerson came home from Chicago to help her mother start the gallery in an old apple barn on the farm she owned. The gallery was open only from two till five in the after-

PENINSULA PLAYERS
AND EDGEWOOD
ORCHARD GALLERY.

noon, because Anne had to work as a waitress in a local restautant to help support it. Her husband, an architect, took a job in a canning factory after she married him, and it took them seven years before they could break even and devote their full time to the gallery.

They have converted the old barn into a work of art in its own right, with carved doors, leaded glass windows, and a brick courtyard with bistro tables. The gallery shows outstanding artwork in all media by more than 140 artists. Anne's daughter, Nell, who literally grew up in a basket on the desk in the gallery, has now taken over as director.

State Highway 42 into Fish Creek crawls down the face of the Niagara Escarpment, with a view that would be quite impressive if it were not blocked by a dense stand of cedar trees. The hallmark of Fish Creek is a main street so narrow that it always seems crowded, even when it isn't. The main entrance to Peninsula State Park is at the east end of Fish Creek, and at the top of the hill above it, next to Gibraltar High School, is the Door County Auditorium, a performing arts center that sponsors a wide variety of music, theater, and dance performances by nationally known artists.

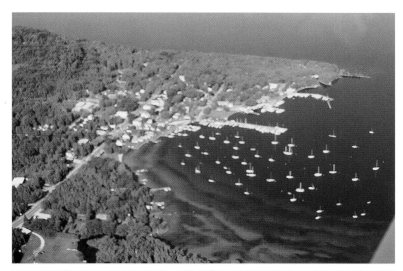

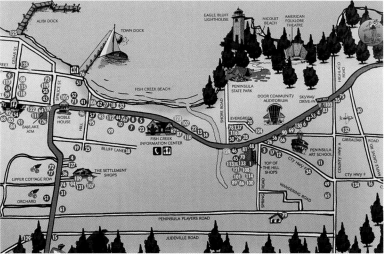

The Door County Auditorium, which was opened in 1991, is the site of the annual Peninsula Music Festival, which Thor Johnson started in 1953 as a small chamber group of musicians who summered in Door County. Initially, the festival was in the high school gymnasium, which could be uncomfortably hot and stuffy on summer evenings, but it was so successful that the community staged a major fund-raising drive to

build the auditorium as a suitable home for it. For three weeks each August, the festival has nine different concerts featuring world-class musicians from major symphony orchestras. It is the social event of the summer in Door County.

Across State Highway 42 from the auditorium is the Peninsula Art School on County Highway F. Madeline Tourtelot started this school in

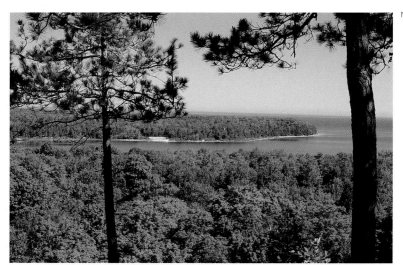

NICOLLET BAY.

FIRE TOWER IN PENINSULA STATE PARK.

1965 with educational workshops and lectures and in 1971 added grant programs to provide space and financial support for artists. In 1980, it started summer classes for nearly 1,000 children. It has four painting studios, a ceramics studio, a metals studio, and a dark room.

Peninsula State Park, one of the gems in the Wisconsin state park system, is west of State Highway 42 between Fish Creek and Ephraim. The park, which was established in 1909, covers six square miles and has 472 family campsites, nineteen miles of biking and hiking trails, a natural sand swimming beach, and an eighteen-hole golf course. The American Folklore Theater, a professional repertory company, stages three different plays each summer week in an open-air amphitheater in the park.

In 1917, Hjalmar R. Holand (page 253) dourly concluded that "the establishment of this park has so far been a bad business investment for Door County," but that did not stop him from urging that the golf course should be adorned with a forty-foot-high totem pole dedicated to Chief Kahquados of the Potawatomi tribe. (This totem pole was another of Holand's many romantic conceits, because the Potawatomis never had them.)

State Highway 42 sweeps in a great curve past the golf course in Peninsula Park and down a steep hill into Ephraim, which has a long-standing unwritten rule that all buildings should be white. The sparkling village, which lines the south and east shores of its embayment, has kept most of its waterfront open to the public, and it commands fine views of the wooded limestone bluffs in the park across the water. Ephraim's sunsets are famous, and the village has ample waterfront from which to watch them.

The hallmark of Ephraim is Wilson's, an ice cream parlor and restaurant that Oscar Wilson, a former candy factory worker in Milwaukee, started in 1906. It still has a period atmosphere, with an old-fashioned jukebox. Next to Wilson's is the former village hall built in self-conscious Scandivavian style in 1927 of local stone. The north

end of the village has the Anderson dock and store, which have been preserved much as they were when they were built in 1858, although the warehouse on the dock has been converted into the Francis Hardy Art Gallery.

It seems appropriate that an ice cream parlor should be the hallmark of Ephraim, which was founded in 1853 as a religious community by members of the Moravian church from Norway, because the village

is the last remaining community in the entire state of Wisconsin where the sale of alcoholic beverages is forbidden. Restaurant owners have agitated for a change, because they can charge higher prices if they can serve wine and beer, but twice, in 1934 and again in 1992, the people of Ephraim have voted to keep the village dry.

Halfway down the hill into Sister Bay State Highway 42 is rejoined by State Highway 57, which follows the lake side, or the "quiet side," of the peninsula. Sister Bay is the commercial node for the northern part of the peninsula.

THE FARM.

A tour of the landmarks on the "quiet" eastern or lake side of Door County begins at the stoplight north of Sturgeon Bay where State Highway 57 forks eastward from State Highway 42 (Fig. 1). "Quiet side" really is a misnomer, because the lake side of the peninsula is a prosperous, bustling resort area in its own right, and it is quiet only in contrast to the much greater development, especially commercial development, on the bay side.

The entrance to The Farm is 1.1 mile east of the stoplight at State Highways 42 and 57. The Farm is a petting zoo that preserves farm history, a place where children and their parents can see, touch, feed, and milk all kinds of farm animals: horses, cattle, donkeys, hogs, goats, sheep, turkeys, ducks, geese, and rabbits. Lucky visitors can watch baby chicks hatching out of eggs or other farm animals being born. The Farm has well-marked nature trails and plots of cultivated crops that are identified by signs. It has restored log buildings with displays of old farm implements and machines. It is a rich educational experience that is also great fun.

The entrance to Bjorklunden is five miles north of Jacksonport. This 425-acre estate, which has more than a mile of unspoiled waterfront, was the summer home of Donald and Winifred Boynton, who bequeathed it to Lawrence College in 1963, with the condition that it be preserved as a "northern campus." One of the principal features of the estate is the wooden chapel that the Boyntons handicrafted between

1939 and 1947 in the distinctive Norwegian *stavekirke* style. It is a popular place for weddings and baptisms.

The Norwegian-style Boynton Lodge is a two-story seminar and conference center with housing for up to 104 people. It hosts weekend retreats and seminars for students during the academic year, and in summer it stages week-long adult education seminars for residents and commuters. In 1999, Bjorklunden started Door Shakespeare, with plays performed outdoors in the lakeside garden from mid-July to mid-August.

The Maxwelton Braes golf course straddles State Highway 57 five miles north of Jacksonport. This course was developed in 1931 by Michael W. McArdle, who was born here, taught in the local elementary school, took a law degree at the University of Wisconsin-Madison, and then went to Chicago, where he became the president of a major national corporation. He developed the luxury golf course and resort on his family's farm. Each guest room had its own telephone and private bath, which was quite extraordinary back in those days, and the resort has attracted many illustrious visitors.

Baileys Harbor, which has one of the few harbors on the Lake Michigan side of Wisconsin, is the largest place on the quiet side of

THE WOODEN CHAPEL
AT BJORKLUNDEN.

Door county. It became the first settlement in the county when a pier, sawmill, and stone quarry were opened here in 1849, and it was the first county seat. Until the Sturgeon Bay Canal was opened, Baileys Harbor was the principal port of the county, shipped forest products, and sold cordwood to fuel steamboats. Woodcutting jobs in the forests lured Germans, Poles, and Finns, some of whom stayed and made farms for themselves on the cutover lands.

At the north end of Baileys Harbor County Highway Q leads east to the Ridges Sanctuary, which is one of the treasures of Door County. The sanctuary was established in 1937 to protect a set of crescent-shaped subparallel ridges that were formed as underwater sandbars, when the waters of Lake Michigan stood higher than they are today. The Ridges Sanctuary is an ecological dream come true, because it has every type of habitat, from open water to mature boreal forest, with a glorious profusion of native wildflowers. Five miles of trails follow the crests of the wooded ridges and cross the swales between them on boardwalks. The Ridges Sanctuary, Toft's Point, and the Mud Lake Wildlife Area have been designated a National Natural Landmark.

The Ridges Sanctuary is a private nonprofit organization. It cooperates closely with two other private nonprofit organizations, the Nature Conservancy and the Door County Land Trust, to protect and preserve the land, the plants, and the scenic beauty of the ecologically unique coastal wetlands and the shallow offshore waters on the eastern side of the peninsula north of Baileys Harbor, which are the home of rare and endangered plants and animals, a critical site for migratory birds, and a major spawning ground for fish (Fig. 23). The Door County Land Trust has conservation easements with individual landowners that permanently protect more than 3,000 precious acres from development.

The Potter's Door Inn and Pottery Studio five miles north of Baileys Harbor has some of the finest examples of stovewood walls in Door County. Many of the houses and barns in the area east of State Highway 57 between Baileys Harbor and Sister Bay have stovewood

NATURE STUDY AT THE
RIDGES SANCTUARY.

ELDRED KOEPSEL.

walls, but they are inside the structures, where the casual traveler can-
not see them.

Koepsel's Farm Market is 5.5 miles north of Baileys Harbor. Eldred
and Mildred Koepsel started the market in 1958. They were proud that
they sold only things they had produced on their own farm, so cus-
tomers were surprised to see mink stoles in a locked glass case next to
the ice cream locker; the Koepsels, like many other dairy farmers, raised

110

minks and fed them on fish scraps and superannuated dairy cows, both of which have been abundant in Door County. One day the Koepsels did not come back to the market after lunch. Someone went across the road to look for them in the farmhouse kitchen and found that both were so exhausted that they had gone to sleep sitting at the table.

The James J. Ingwersen gallery is 7.9 miles north of Baileys Harbor and 1.6 mile east on Old Stage Road. Jim is a superb artist who specializes in presentation portraits of distinguished people. Jim was born in Evanston, Illinois, in 1929. He had a studio in Twin Lakes, "where the only culture was about thirty-nine bars," so in 1970 he came to Door County and bought a century-old farm with splendid log buildings that he has turned into a magnificent gallery.

Jim is a conspicuous manifestation of the snowball effect that has played such an important role in the growth of Door County. He was in the vanguard of artists who have taken up permanent residence in the county, because of its cultural attractions, but in turn they have become cultural attractions in their own right.

State Highway 57 rejoins State Highway 42 halfway down the hill into Sister Bay, whose strategic location has made it the principal com-

JIM INGWERSEN.

mercial center for Door County north of Sturgeon Bay. The main street in Sister Bay (and in all of the other villages on the peninsula) is a line of stores and other business buildings on their own individual parcels of ground, and the village has no solid block of contiguous business buildings of the sort one might expect in a conventional downtown.

The hallmark of Sister Bay is Al Johnson's Swedish restaurant with the goats grazing on the grass on the roof. Al started his restaurant in 1948 in a former grocery store. In 1973, he imported logs and crafts-men from Norway to construct an authentic Norwegian building with grass on its roof. Training the goats to climb a ladder onto the roof was a challenge, and local folklore has tales about the person who slipped from the ladder and broke his arm in the process. Each summer Al brings young women from Sweden to work in the restaurant, which has been so successful that he has had to enlarge it six times.

Across the street from the restaurant is a large marina with 100 slips and a harbormaster building with showers and restrooms. The vil-lage straggles along the shore for two miles, with another large marina at the north end of town, across the street from new luxury condomini-ums that are priced at $700,000 and up.

The Seaquist Orchards Farm Market two miles north of Sister Bay was recognized as an Outstanding Farm Market of the Year in 2005 by

AL JOHNSON'S RESTAURANT IN SISTER BAY.

the North American Farmers' Direct Marketing Association. Seaquist Farms produces more than forty percent of Door County's cherries, and it is the largest cherry grower in the county. Dale Seaquist, the family patriarch, takes visitors on delightful tours of the orchards.

The crest of the hill south of Ellison Bay on State Highway 42 has one of the finest views on the peninsula. On the Garrett Bay Road, 0.3 mile north of Ellison Bay, is the entrance to The Clearing, a folk school for adults. The Clearing was founded by Jens Jensen, whom *The New York Times* called the "dean of American landscape architecture" at the time of his death in 1951. Jensen was to landscape architecture what Frank Lloyd Wright was to architecture. He initiated the Prairie Style of landscape design that emphasized the use of local (that is, indigenous or native) plants, and he was responsible for designing many of Chicago's finest parks and palatial estates and for presering key natural areas in the Midwest, such as the Indiana Dunes (now a national lakeshore). Jensen founded The Clearing in 1935 to give visitors a place "to clear their minds" by getting back to nature. It was taken over by the Wisconsin Farm Bureau when Jensen died, and in 1988 it became an independent nonprofit corporation. In 2006, The Clearing entered into a conservation easement agreement with the Door County Land Trust that permanently prevents the subdividision or development of its 128 acres.

The Clearing has a rustic campus of handsome stone buildings and log buildings with massive stone chimneys. It offers an elaborate program of more than 100 courses in the arts and crafts, humanities, and natural sciences. The summer program has week-long classes for twenty-five to thirty-five resident students who live and eat with their instructors. The winter program of one- and two-day courses is designed for Door County residents. It is taught by volunteer instructors drawn from the county's remarkable pool of artists and craftspeople.

State Highway 42 has a unique sinuous stretch between Gills Rock and Northport, where it once weaved back and forth between the telephone poles. The Washington Island ferry departs from Northport

every half hour during the summer months. At one time, Washington Island was home to the largest group of Icelanders in Wisconsin, but they have all moved to Racine. At another time the island was a commercial potato-growing area, but the old potato fields are now abandoned. Today, the economy of Washington Island, like most of Door County north of the 45th parallel, is based on serving summer visitors.

At the northeastern corner of Washington Island is Rock Island, a twenty-minute ferry ride from Jackson Harbor, from which the ferry leaves every hour. Rock Island guards the entrance to the principal navigational channel from Lake Michigan to Green Bay, and as early as 1839 the northern tip of the island had a lighthouse, one of the very first on the Great Lakes. At the southwestern corner of Rock Island archaeologists have excavated the site of a palisaded Indian fishing village which might also have served as a French fur-trading post. After 1835, a few white fishermen were based on Rock Island, but by 1860 the white settlers had moved across to Washington Island.

Chester H. Thordarson, a Chicago-based inventor who had made a fortune as a manufacturer of electrical equipment, was proud of his Icelandic ancestry. He had visited the Icelandic settlements on Wash-

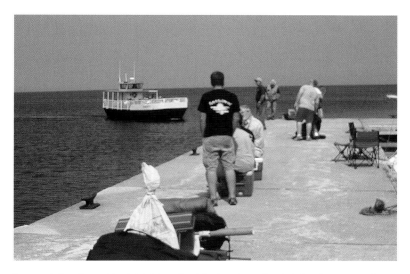

ington Island, and in 1910 he decided to buy Rock Island as a vacation site for his employees and friends. On the shore he built a massive, gray limestone boathouse, 108-by-68-feet, with a red tile roof, and above the boathouse was an enormous Great Hall that was his romantic vision of a Viking banquet hall. The Great Hall has large timber beams, great tiered chandeliers with racks of antlers on each tier, a huge fireplace, and massive oak chairs and tables carved with Icelandic motifs. Thordarson brought a woodworker from Iceland, who spent three years carving the furniture.

Thordarson died in 1945, and in 1964 the State of Wisconsin bought Rock Island from his heirs for conversion into a state park for hikers, campers, and backpackers. Thordarson had kept most of the island in its natural state, and it is still mostly wooded, with more than a dozen miles of nature trails through areas teeming with wildlife. The forty primitive campsites have only fire rings and picnic tables, and campers must pack in everything they need, because visitors are not allowed to use automobiles, bicycles, or other wheeled vehicles in the island, although park rangers do tootle around on small motorized vehicles, and they can help in a pinch.

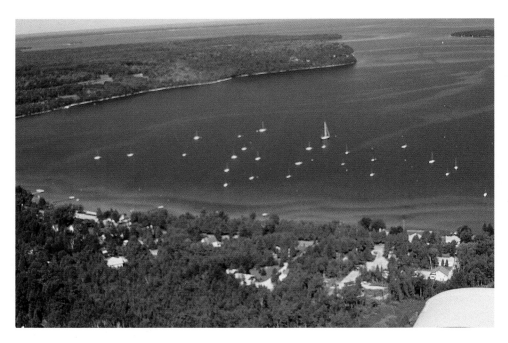

AERIAL VIEW OF EAGLE HARBOR IN EPHRAIM.

Door County, Wisconsin, is and will remain a premier tourist destination, with more than two million visitors a year. Early visitors were attracted by the craggy limestone bluffs of the Niagara Escarpment, sandy beaches, hundreds of miles of shoreline on Green Bay and Lake Michigan, mild summer temperatures, clean air, quaint little villages nestled snugly at the heads of picturesque pocket harbors, and restful rural roads embowered by thick canopies of cedar, beech, and aspen.

Door County was hard to reach even after a railroad finally was completed to the city of Sturgeon Bay in 1894, and most early visitors traveled by slow lake steamer. The trip took so much time that the county only attracted people with long summer vacations who sought a haven of peace and quiet. They placed their stamp on the county, whose natural beauty has attracted many artists, and it has become a renowned center of the visual and performing arts. The construction of better highways has stimulated the growth of tourism since World War II, but the county still has remarkably little commercial recreational development.

At first, visitors rented rooms for the summer from local residents, but before long they began to buy shoreline sites on which they built their own rustic summer cottages. Over time, many of these cottages have been winterized and upgraded into retirement homes. Some own-

ers also have winter homes in the Sunbelt. We have no idea how many, because the owners were counted in their Sunbelt "second homes," rather than in Door County, when the last census of population was taken in April 2000.

Door County has developed the infrastructure appropriate to a major tourist destination. It has six state parks, more than any other county in the United States, fourteen county parks, many private camp-grounds, and a vast range of outdoor activities. It also has a wondrous range of lodging places, eating places, and shops of all kinds. Most of the tourist-oriented businesses in the county are small family-owned and family-operated affairs, because large national chains are reluctant to invest in an area where sales are crammed into three brief months between Memorial Day and Labor Day.

Many entrepreneurs have discovered to their sorrow that Door County is a tough place to do business. Competition is intense during the brief summer season, and sales depend on the whims and caprices of visitors. Each year some businesses go broke, and next year eager new entrepreneurs occupy the premises. Signs proclaiming "Under new management" are common.

Most of the tourist-related activities in Door County are north of the town of Sturgeon Bay. The heaviest concentration is on the western, or Green Bay, side of the county, from Egg Harbor north to Sister Bay. The eastern, or Lake Michigan, side is "the quiet side" only in compari-son with the bustling bay side. The southern half of the county, which has the distinctive Belgian area in its southwestern corner, is almost another world, because it remains largely untouched by tourism. Small dairy farms dominate the placid rural landscape.

Today, most of the dairy farms in Door County are laboring, because they are too small to provide an acceptable level of living for a contemporary American family, and at least one member of the farm family must bring in off-farm income to support them. The farmers com-plain bitterly that the price of milk is too low, whereas in fact their costs

of producing milk are too high. They can only reduce their production costs by greatly increasing their scale of operation, which few of them can afford to do.

The number of dairy farms in Door County has been declining steadily since 1935, and it probably will continue to decline. Massive barns and silos, which once were the hallmarks of prosperous dairy farms, still adorn the rural landscape, but close inspection shows that few of them still house cows, and many are in various states of abandonment. Much former farmland also has been abandoned, especially in the northern part of the county, where the soils are thinner, and erstwhile fields and pastures are growing up in brush.

Extensive areas of former cherry orchards north of Sturgeon Bay also have been abandoned, and the orchards for which Door County once was famous are a mere shadow of what they once were. Few cherry growers have orchards large enough to compete with lower-cost producers in other regions, and most have only enough to produce fruit for their roadside stands. The gaunt skeletons of dead cherry trees stand in long forlorn rows in many old orchards, and they, too, are growing up in brush.

Dense woods completely covered Door County when white settlers first saw it, and the county is becoming wooded once again. The settlers laboriously cleared the woods for farmland. Forest products were an important source of income in the early days, and trees were the raw material for constructing sturdy log buildings, many of which are now camouflaged beneath more modern siding. The primeval forests are long gone, except in a few small preserves, but today brush and trees are rapidly encroaching on old orchards, fields, and meadows that are no longer appropriate for modern farm operations, and soon much of the northern part of the county will be cloaked with second-growth woodland.

The dense primeval forests of the peninsula forced early settlers to look to the waters that define it, and the people of Door County—

residents and visitors alike—have looked to the water ever since. Commercial fishing for whitefish, perch, chub, and smelt has dwindled to a few hardy souls, but many charter boats are available for hire by those who seek sports fish, such as salmon and trout, which fight back dramatically.

More than 6,000 recreational boats of all types and sizes are registered in the county, and private docks and piers pack the shores. Most of the shoreline is privately owned and inaccessible to visitors; shoreline properties sell for exorbitant prices, and few are on the market. Every village has one or more marinas where visitors can tie up their boats, and in summer pleasure boats congest the waters of Sturgeon Bay. You can see hundreds of them as you drive across the Bayview bridge on the bypass.

The city of Sturgeon Bay is the leading shipbuilding center on the American side of the Great Lakes, and the shipyards are the principal industrial employer in Door County. Shipbuilding, unfortunately, is an unstable boom-and-bust business, and the yards must constantly compete with yards in other counties where labor is cheaper. Boosters are eager to diversify the local economy by attracting other industries, but the prosperous city of Green Bay is an attractive intervening opportunity that stands between the county and the national market.

The future of Door County seems to lie in tourism, but even tourism is not without its problems. It remains stubbornly seasonal. The conversion of summer cottages into winterized retirement homes might extend the visitor season, but it will also widen the chasm between affluent visitors and low-income local people. Much of the new housing built in the county is extremely expensive, and the county has a serious shortage of affordable housing.

An increasing elderly retired population will put stress on health services and other public services. Taxes will have to rise to provide the services that affluent people demand, but rising taxes place a heavy burden on the workers who serve the elderly and on all other low-

income people, such as retirees with fixed incomes. People the county needs can no longer afford to live there.

Door County must compete for affluent visitors with attractive areas in the Sunbelt, in the Caribbean, in Hawaii, and in other more distant parts of the world. Conversely, the county might reach a saturation point if the number of visitors becomes so great that it discourages others from coming.

The natural beauty of Door County attracts millions of visitors each year, but the very beauty that attracts them is fragile and must be protected assiduously. Everyone knows that the soluble strata of the Niagara dolomite create problems of freshwater supply and wastewater disposal, but visual pollution can be equally serious. A single, badly sited, unsightly development or megamansion can mutilate the landscape and desolate the pleasure of everyone else.

These problems are real, but they are not insurmountable. Many public agencies and private groups are deeply concerned about the future of Door County, and they are working diligently to protect it. Conservation Groups, such as the Door County Land Trust, the Ridges Sanctuary, and the Nature Conservancy, deserve the unstinting support and encouragement of everyone who loves the county.

And there is much to love for those who appreciate the beauty of nature, because Door County is still a haven of peace and quiet. In summer, the villages of the county may be congested with visitors, to be sure, and the highways that course the western and eastern sides of the county are heavy with traffic, but only a mile or so inland the tree-shaded rural roads are virtually deserted, and the countryside seems empty.

The crest of the escarpment overlooking Green Bay is a splendid place to appreciate the glory of Door County. On stormy days the majestic panorama of nature unfolds as dark clouds boil inexorably in across the bay, but most of the time only a soft breeze ruffles the trees, and summer days are pleasantly warm but only rarely hot. The sun

glints off the distant waters of the bay, which bustle with excitement. Watercraft dart to and fro along the shore, and farther out sailboats jockey for position at the start of a regatta, while a lonely paraglider soars peacefully overhead.

Late afternoon is time for a quiet drink and good conversation on the patio. Birds seek their nests in the trees, and right on schedule a dainty doe and her twin fauns bounce warily across the lower meadow, while the setting sun briefly enamels the western sky with delicate pastel shades. The night air is so clear that the stars seem almost close enough to touch, and the constellations become good friends as they wheel slowly across the vault of heaven. The summer nights are cool enough for peaceful slumber, and for those who can stay until fall the aurora borealis (or northern lights) flares up in the northern sky.

What more could anyone want?

Hjalmar R. Holand was an Ephraim resident who published a two-volume history of Door County in 1917. He was an inveterate yarn-spinner and had a wondrous eye for a good story. Some of his best tales were culled from the early pages of the *Door County Advocate*, and I cannot resist including my own favorite story about the way Door County residents used to amuse themselves. I have been unable to track down the date of the original article, which is reprinted in the first volume of Holand's *History of Door County, Wisconsin* (pages 400–02).

A farmer living a few miles from the Village of Egg Harbor invited his neighbors to come and spend a sociable evening at his home. It is not at all likely that his hospitable offer would have been refused even though no other attraction than a dance had been promised, for amusements are always welcome in that locality so that the giver of a party is not obliged to send out a press-gang in search of guests, as was the case of the gentleman whose marriage feast is recorded in the New Testament. But having backed up his invitation with the assurance that there would be plenty of beer for women, children and other temperance people, and lashings of whisky for those who preferred to get drunk with neatness and dispatch, it is hardly necessary

to say that he had a crowded house with "standing room only" for those who arrived after 7 o'clock.

It will be readily understood that under the inspiriting influence of abundant grog the evening had not far advanced before there was such a tremendous sound of revelry that had there been any police in the vicinity they would have 'pulled' the house and brought the entertainment to an abrupt conclusion. But there being no legal impediments to the festivities, they were conducted upon such a free and easy scale as would have astounded those who lived in a more civilized community. Long before midnight the fun became boisterous and decency received the grand bounce. It was while affairs were in this interesting state that one of the men, who was possibly a little more tipsy than the rest, laid the foundation for a first-class row. The whisky he had drunk excited his affectionate instincts to such a degree that regardless of his surroundings he made advances of a decidedly indelicate character to one of the women, who immediately proclaimed the fact by a squeal that drowned all other noise in the house. Whether her displeasure arose from offended virtue, or whether she was enraged because her amorous friend had not chosen a more appropriate locality for his demonstration, is an unguessable conundrum. At any rate, the fair creature raised such a tremendous bobbery as to draw upon herself and her admirer the attention of the whole party. Among these was the woman's son, who had no sooner learned the cause of the trouble than he struck out from the shoulder with such vigor and precision that the offending man took a tumble under the table, where he lay for a few minutes trying to discover how many of his teeth had been loosened.

It might be supposed that a man who had committed such a gross offense against the moralities would have no sympathizers, and that the verdict of the crowd would be that he should be kicked as long as kicking was good for him. This would doubtless have been the opinion of the guests if they had been sober, but being drunk they

took a different view of the matter. It should also be remembered that up to this time there had been no fight, and that all hands had taken just enough whisky aboard to make them itch for a scrimmage. The consequence was that within two minutes every man in the room was endeavoring to put a head on his neighbor. No one appeared to know or care what he was fighting about, the chief aim of each belligerent being to put in his knuckles where they would do the most good. It did not take the ladies long to realize that the men were conducting a riot with so much skill and energy that the assistance of the fair sex was entirely unnecessary. In order, therefore, to give the combatants abundant room, and also to get themselves out of harm's way, the women bundled themselves and the children off to the rooms upstairs. The terrific uproar below caused several of them to go into hysterics, and when their condition became known in the lower regions some of the men went up to their relief. The additional burden thus put on the chamber floors was more than they could support and the joists gave way with a crash, precipitating men, women and children and furniture upon the heads of the pugnacious gentlemen on the ground floor. For about five minutes that floor presented an appearance to which no description can do justice. Many of the ladies were standing on their heads, their limbs sticking out of the heap in every direction like the spokes of a busted cart wheel, while their striped stockings waved in the air like signals of distress at the masthead of a water-logged scow. The children screamed, the women shrieked, and the men swore as in their efforts to disentangle the squirming mass of humanity they found that a woman was being pulled out of the heap in different directions. When at last order was restored everybody was surprised to find that nobody was either killed or seriously hurt. The fighting party had escaped the falling floor, and the people from above were none the worse for their tumble. The accident had at least one good result. It brought the row to an end, and now all hands were as ready to bind up their neighbor's wounds as they had lately been to inflict them. As

soon as the women recovered from their fright they began to count noses to learn whether any one had been lost. The inventory showed that one of the children was missing, and for a short time the mother was distracted. The young kid was finally discovered in a flour barrel into which it had fallen when the floor gave way, and was restored to its mother's arms along with several pounds of "double extra" bread-stuffs that had powdered the infant from head to foot.

Having almost torn the house to pieces, pounded each other for about an hour, and nearly succeeded in killing the women and children, it was mutually agreed that there had been enough fun for one night. The guests therefore collected their wraps, took one more drink all around in token that they bore no ill-will toward one another, and departed assuring their host that they had spent a most delightful evening and that his party had been the most successful affair of the season.

FIG. 1

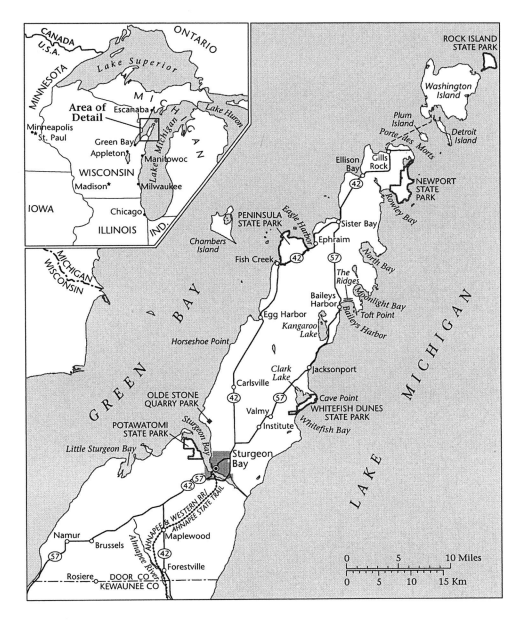

FIG. 2

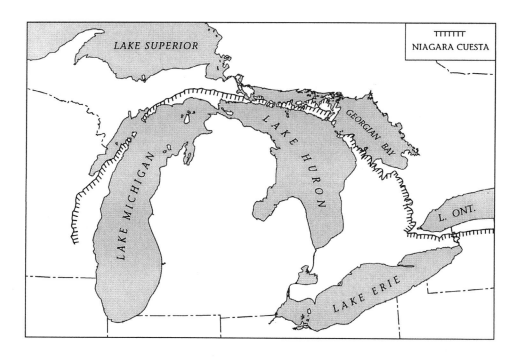

LAKE SUPERIOR

NIAGARA CUESTA

LAKE MICHIGAN

LAKE HURON

GEORGIAN BAY

L. ONT.

LAKE ERIE

FIG. 3

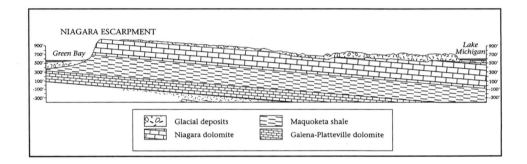

FIG. 4

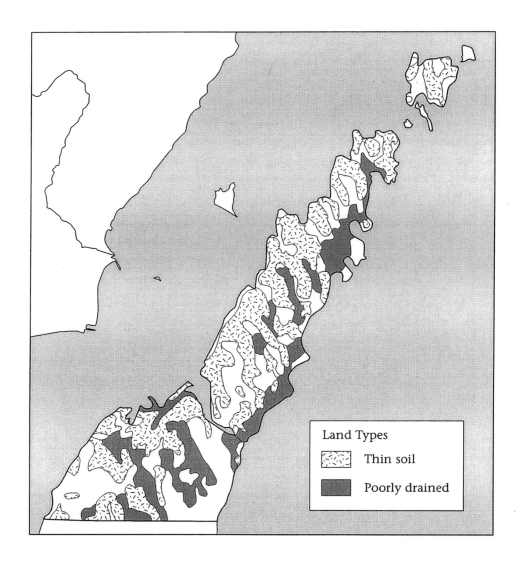

Land Types

Thin soil

Poorly drained

FIG. 5

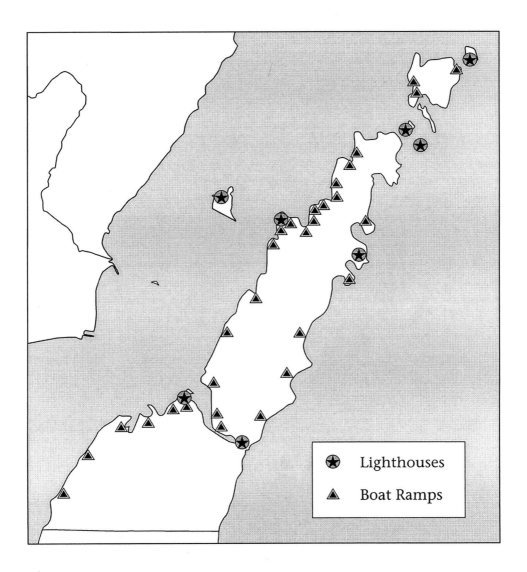

Lighthouses

Boat Ramps

FIG. 6

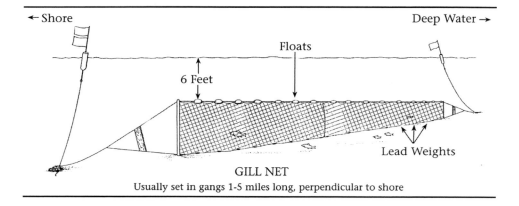

← Shore

Deep Water →

Floats

6 Feet

Lead Weights

GILL NET

Usually set in gangs 1-5 miles long, perpendicular to shore

FIG. 7

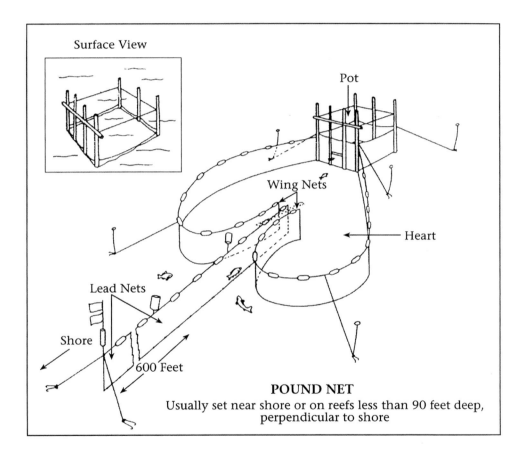

Surface View

Pot

Wing Nets

Heart

Lead Nets

Shore

600 Feet

POUND NET
Usually set near shore or on reefs less than 90 feet deep,
perpendicular to shore

135

FIG. 8

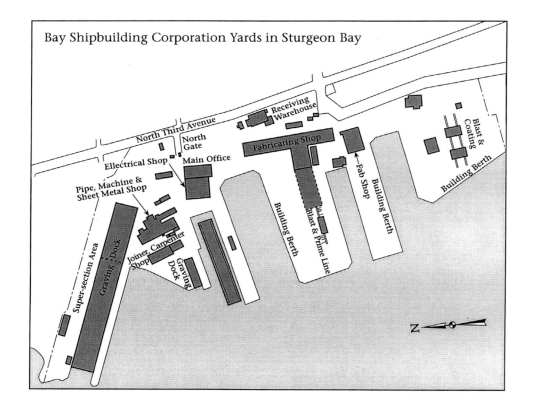

Bay Shipbuilding Corporation Yards in Sturgeon Bay

North Third Avenue

Receiving Warehouse

North Gate

Fabricating Shop

Electrical Shop

Main Office

Blast & Coating

Pipe, Machine & Sheet Metal Shop

Fab Shop

Building Berth

Building Berth

Super-section Area

Graving Dock

Joiner Carpenter Shop

Graving Dock

Building Berth

Blast & Prime Line

Building Berth

N

FIG. 9

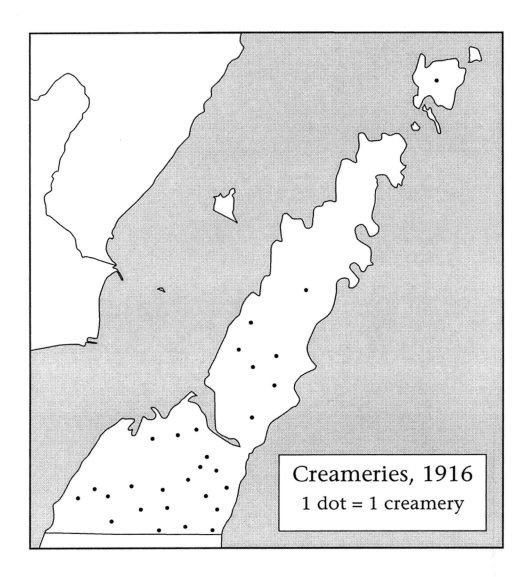

Creameries, 1916
1 dot = 1 creamery

FIG. 10

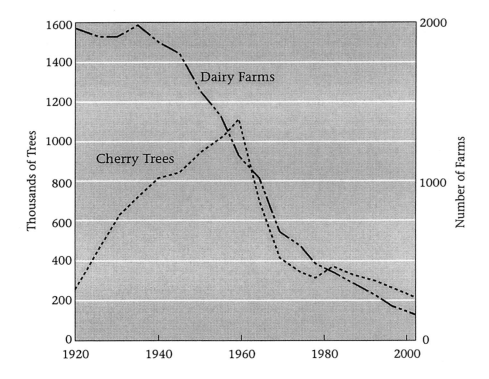

FIG. 11

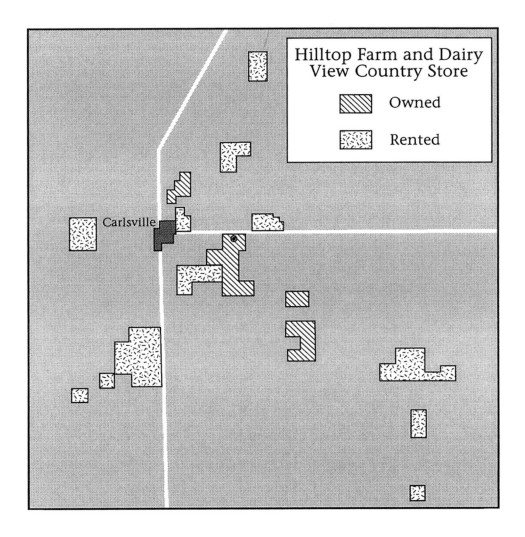

Hilltop Farm and Dairy
View Country Store

Owned

Rented

Carlsville

FIG. 12

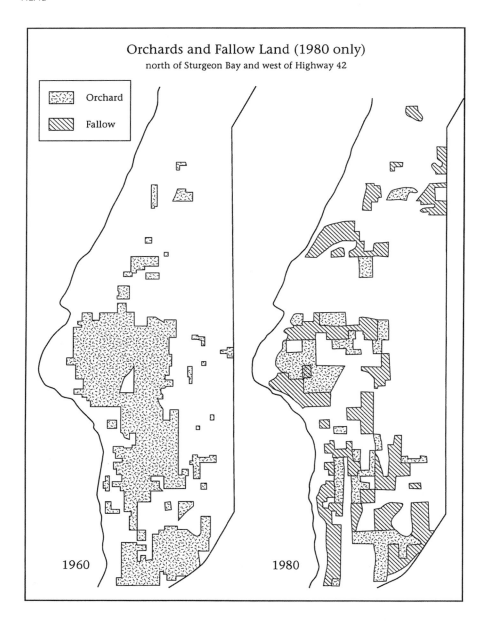

Orchards and Fallow Land (1980 only)
north of Sturgeon Bay and west of Highway 42

Orchard
Fallow

1960

1980

FIG. 13

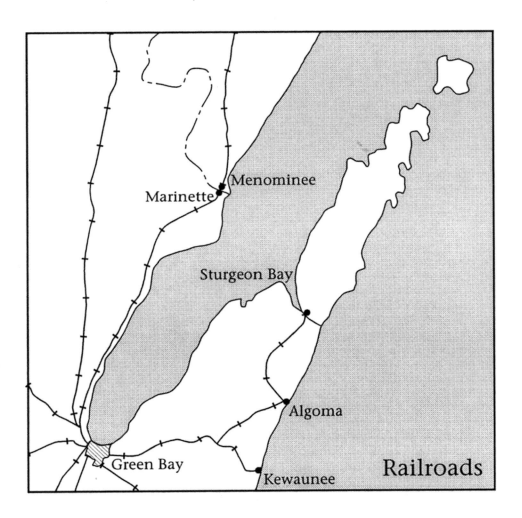

Railroads

FIG. 14

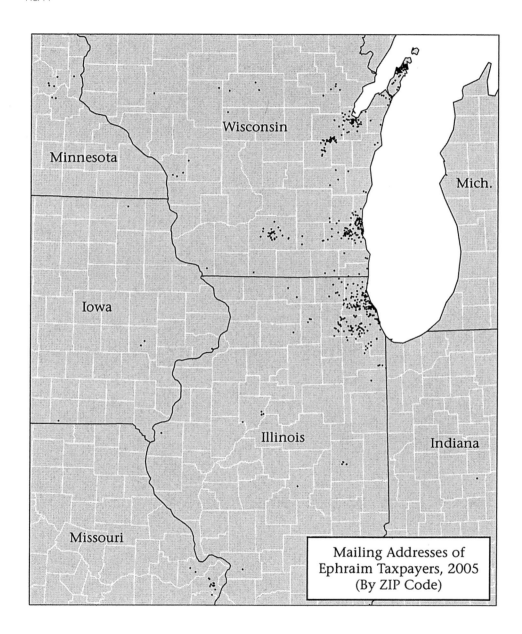

Mailing Addresses of
Ephraim Taxpayers, 2005
(By ZIP Code)

FIG. 15

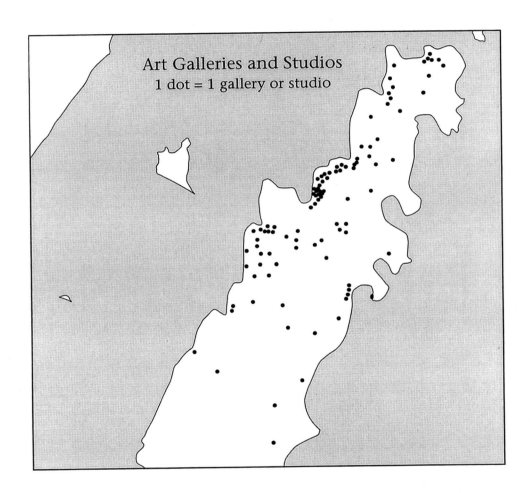

Art Galleries and Studios
1 dot = 1 gallery or studio

FIG. 16

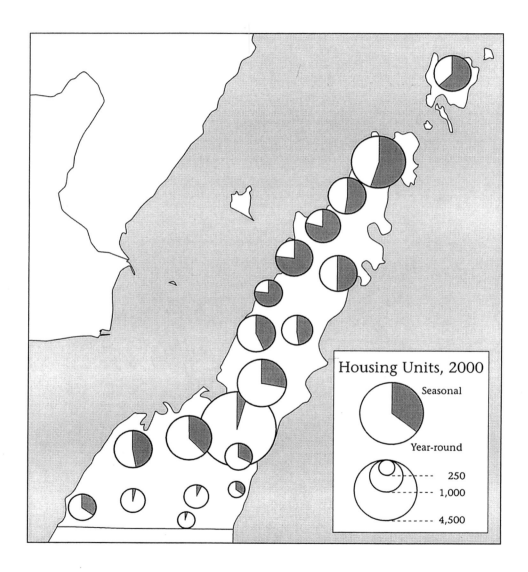

Housing Units, 2000

Seasonal

Year-round

- - - - 250
- - - - 1,000
- - - - 4,500

FIG. 17

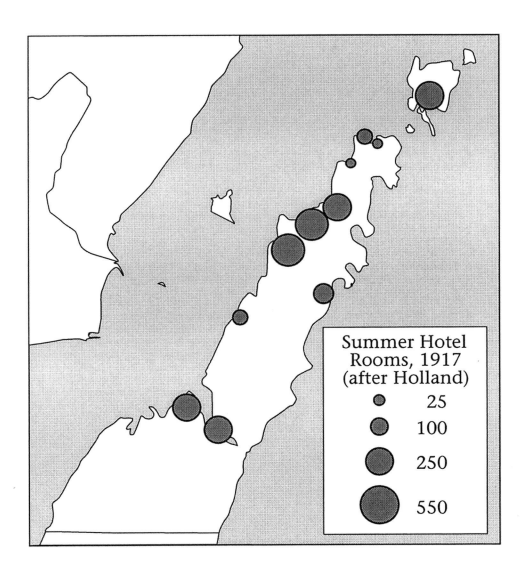

Summer Hotel
Rooms, 1917
(after Holland)

25

100

250

550

FIG. 18

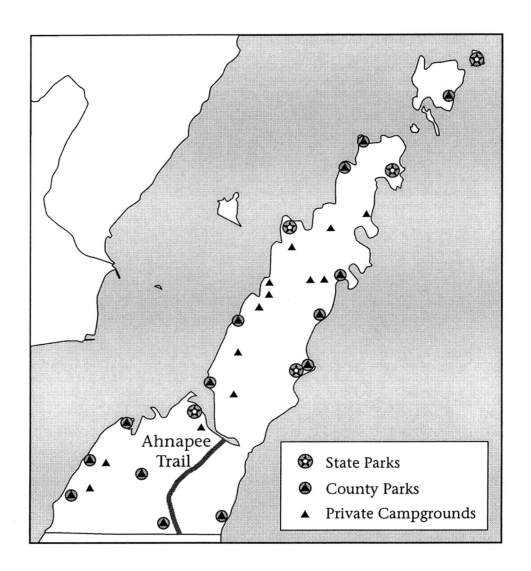

Ahnapee
Trail

State Parks
County Parks
Private Campgrounds

FIG. 19

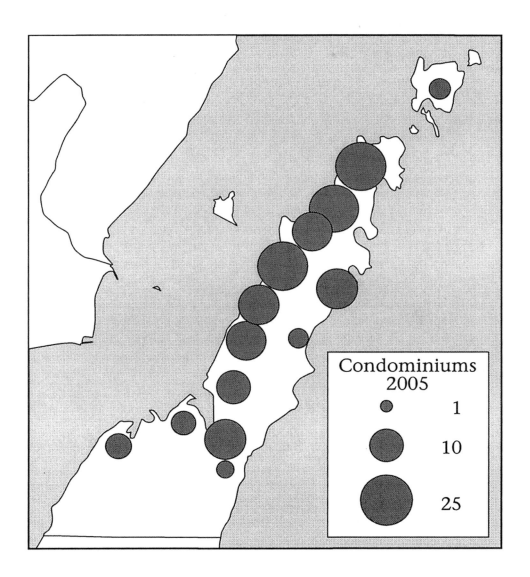

Condominiums
2005

1

10

25

FIG. 20

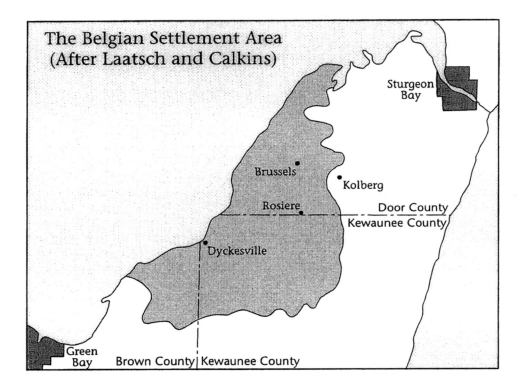

The Belgian Settlement Area
(After Laatsch and Calkins)

Sturgeon Bay

Brussels •

• Kolberg

Rosiere • — Door County
— Kewaunee County

• Dyckesville

Green Bay

Brown County | Kewaunee County

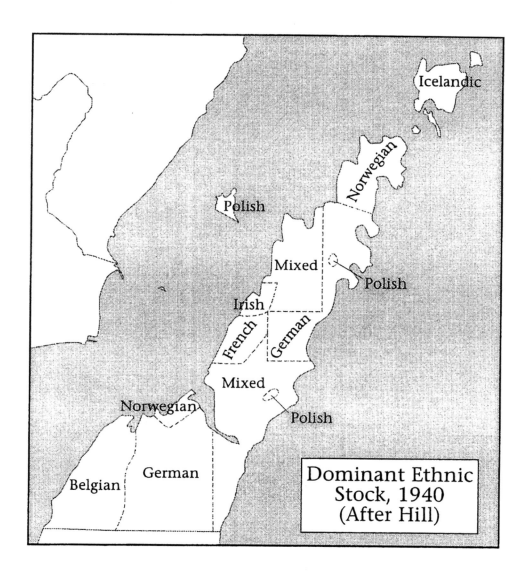

FIG. 21

Icelandic

Norwegian

Polish

Mixed

Polish

Irish

French

German

Mixed

Polish

Norwegian

Belgian

German

Dominant Ethnic
Stock, 1940
(After Hill)

149

FIG. 22

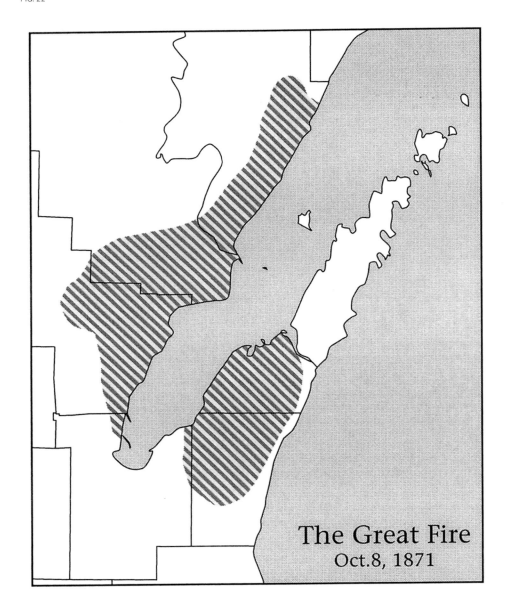

The Great Fire
Oct.8, 1871

FIG. 23

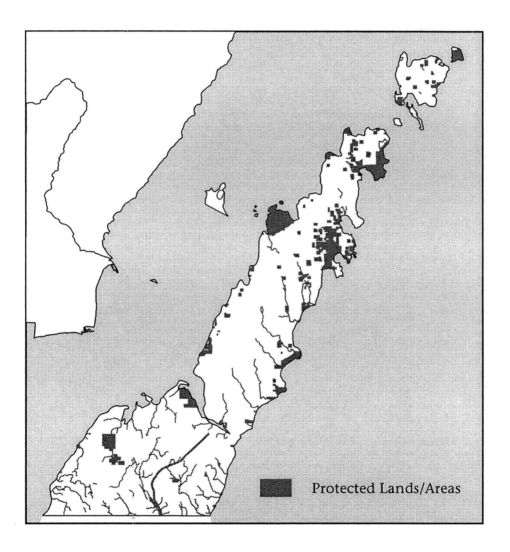

Protected Lands/Areas

Note to the Reader: The entries below represent text references and suggested readings for the student, scholar, and general reader.

Bay, Ida Margaret, "Williamsonville," The Peninsula (Door County Historical Society), Number 4, May 1959, 14–16.

Bogue, Margaret Beattie, *Around the Shores of Lake Michigan: A Guide to Historic Sites* (Madison: University of Wisconsin Press, 1982).

Burton, Paul and Frances, *Door County Stories and Stories from the Belgian Settlement* (Ephraim, WI: Stonehill Publishing, 2003).

Calkins, Charles F., and William G. Laatsch, "The Belgian Outdoor Ovens of Northeastern Wisconsin," *Pioneer America Society Transactions*, Vol. 2 (1979): 1–11.

Charles, Craig, *Exploring Door County* (Gwinn, Michigan: Avery Color Studios, 2003).

Church, Charles F., *Easy Going: A Comprehensive Guide to Door County* (Madison, WI: Tamarack Press, 1977).

Curtis, James T., *The Vegetation of Wisconsin* (Madison: University of Wisconsin Press, 1959).

Defnet, Mary A., Jean Ducat, Thierry Eggerickx, and Michel Poulain, *From Grez-Doiceau to Wisconsin* (Brussels, Belgium: De Boeck-Wesmael, 1986).

Door County Advocate, twice weekly.

Door County Land and Water Resource Management Plan (Sturgeon Bay, WI: Door County Soil and Water Conservation Department. 2005).

Ellis, William S., "Wisconsin's Door Peninsula: 'A Kingdom so Delicious,'" *National Geographic Magazine* (March 1969): 346–71.

Geib, W. J., Carl Thompson, and H. V. Geib, *Soil Survey of Door County*, Wisconsin, Washington: Government Printing Office, 1918.

Haines, Donald A., and Rodney W. Sando, *Climatic Conditions Preceding Historically Great Fires in the North Central Region*, USDA Forest Service Research Paper NC-34 (St. Paul, MN: North Central Forest Experiment Station, Forest Service, U. S. Department of Agriculture, 1969).

Hart, John Fraser, "Resort Areas in Wisconsin," *Geographical Review*, Vol. 74, No. 2 (April 1984): 192–217.

Harris, Chan, "A & W: Mr. Decker's Railroad," Chapter Nine in Stanley H. Mailer, *Green Bay & Western: The First 111 Years* (Edmonds, Washington: Hundman Publishing, 1989).

Henderson, David B., *Impacts of Ethnic Homogeneity and Diversity on the Cultural Landscape of Door County, Wisconsin*, unpublished MA thesis, University of Wisconsin-Milwaukee, 1968.

Holand, Hjalmar R., *History of Door County, Wisconsin: The County Beautiful* (Chicago: S. J. Clarke, 1917; reprinted by William Caxton, Ltd., Ellison Bay, Wisconsin, 1993).

Jensen, Jens, *Siftings: A Major Portion of the Clearing* (Chicago: Ralph Fletcher Seymour, 1956; reprinted as *Siftings*, with a foreword by Charles E. Little and an afterword by Darrel G. Morrison, by the Johns Hopkins University Press, 1990).

Jensen, Trygvie, *Wooden Boats and Iron Men: History of Commercial Fishing in Northern Lake Michigan and Door County, 1850–2005* (De Pere, WI: Paisa (Alt) Publishing Company, 2007).

John, Stephen F., *Door County Citizens' Guide to Small Wastewater Systems* (Fish Creek, WI: Door County Environmental Council, 2003).

Kahlert, John, *Early Door County Buildings and the People Who Built Them* (Baileys Harbor, WI: Meadow Land Publishers, 1976).

Key to the Door . . . Illustrated (Sturgeon Bay, WI: Bay Publications, annual).

Laatsch, William G., and Charles F. Calkins, "The Belgian Roadside Chapels of the Door Peninsula, Wisconsin," *Journal of Cultural Geography*, Vol. 7, No. I (1986): 1–12.

_____, "Belgians in Wisconsin," in Allen G. Noble, editor, *To Build a New Land: Ethnic Landscapes of North America* (Baltimore: Johns Hopkins University Press, in association with The Center for American Places, 1992), 195–210.

Lotz, M. Marvin, *Discovering Door County's Past: A Comprehensive History of the Door Peninsula in Two Volumes* (Fish Creek, WI: Holly House Press, 1994).

Lukes, Roy, *Toft Point: A Legacy of People and Pines* (Egg Harbor, WI: Nature-Wise, 2004).

Menu Guide: A Guide to Door County Restaurants (Sister Bay, WI: Door Reminder, annual).

Palmquist, John C., editor, *Wisconsin's Door Peninsula: A Natural History* (Appleton, WI: Perin Press, n.d.).

Platt, Robert S., "A Detail of Regional Geography: Ellison Bay Community as an Industrial Organism," *Annals of the Association of American Geographers*, Vol. 18, No. 1 (June 1928): 81–126.

Red Tart Cherries in Wisconsin: Production, Harvesting, Marketing, Utilization, Report of a committee appointed by the Dean of the College of Agriculture, University of Wisconsin, Madison, 1962.

Rosen, Carol, *Karst Geomorphology of the Door Peninsula*, unpublished MS thesis, University of Wisconsin-Milwaukee, 1984.

Thomas, Bruce, *Door County: Wisconsin's Peninsular Jewel* (New Berlin, WI: Sells Printing Company, 1993).

Thwaites, F. T., and Kenneth Bertrand, "Pleistocene Geology of the Door Peninsula, Wisconsin," *Bulletin of the Geological Society of America*, Vol. 68 (1957): 831–79.

Tishler, William H., "Stovewood Architecture," *Landscape*, Vol. 23, No. 3 (1979): 28–31.

_____, *Door County's Emerald Treasure: A History of Peninsula State Park* (Madison: University of Wisconsin Press, 2006).

Wain-e-saut, Chief, and Chief Keohuch, *Tschekatch'ake'mau III: Recollections of Chief Roy J. Oshkosh* (privately printed, n.d.).

Wellhead Protection Plan: Sturgeon Bay Utilities Municipal Wells (Sturgeon Bay, WI: Door County Soil and Water Conservation Department, 2003).

Wells, Robert W., *Fire at Peshtigo* (Englewood Cliffs, NJ: Prentice-Hall, 1968).

Whittlesey, Derwent S., "Field Maps for the Geography of an Agricultural Area," *Annals of the Association of American Geographers*, Vol. 15, No. 2 (1925): 187–91.

WPA Guide to Wisconsin (New York: Duell, Sloan, and Pearce, 1941; reprinted by the Minnesota Historical Society Press, 2006).

Zurawski, Joseph, *Door County, Wisconsin* (Charleston, SC: Arcadia Publishing, 1998).

_____, *Sister Bay, Wisconsin* (Charleston, SC: Arcadia Publishing, 2000).

J ohn Fraser Hart was born in 1924 in Staunton, Virginia, and he was raised in Virginia and Atlanta. He attended Hampden-Sydney College and the University of Georgia Extension Division in Atlanta, received an A.B. in classical languages from Emory University, studied geography at the University of Georgia, and completed an M.A. and a Ph.D. in geography at Northwestern University. His academic honors include the first Lifetime Achievement Award from the Southeastern Division of the Association of American Geographers in 1987, a John Simon Guggenheim Memorial Foundation Fellowship in 1982–1983, the presidency of the Association of American Geographers in 1979–1980, the editorship of the *Annals of the Association of American Geographers* from 1970 to 1975, an Award for the Teaching of Geography, College Level, from the National Council for Geographic Education in 1971, and a Citation for Meritorious Contributions to the Field of Geography from the Association of American Geographers in 1969. He is the author, co-author, and editor of sixteen books, among them *The Land That Feeds Us* (W. W. Norton, 1991), for which he received the John Brinckerhoff Jackson Prize from the Association of American Geographers and the Publication Award of 1992 from the Geographic Society of Chicago. (See pages 161–62 for a complete list of books by the author.) John Fraser Hart is a professor of geography at the University of Minnesota.

Southeastern Excursion Guidebook, with Eugene Cotton Mather, Publication No. 3 of the XVIIth International Geographic Congress (Washington, DC: International Geographical Union, 1952).

The British Moorlands: A Problem in Land Utilization (Athens: The University of Georgia Press, 1955).

The Southeastern United States, Searchlight Book No. 34 (Princeton: Van Nostrand, 1967).

U.S. and Canada (Boston: Ginn, 1967).

Regions of the United States, editor (New York: Harper and Row, 1972).

The Look of the Land (Englewood Cliffs, NJ: Prentice Hall, 1975).

The South (New York: Van Nostrand, 1976).

Cultural Geography on Topographic Maps, with Karl Raitz (New York: John Wiley, 1975).

The Land that Feeds Us (New York: W. W. Norton, 1991).

Our Changing Cities, editor (Baltimore: The Johns Hopkins University Press, in association with the Center for American Places, 1998).

The Rural Landscape (Baltimore: The Johns Hopkins University Press, in association with the Center for American Places, 1998).

The American Farm, adapted by Gail Kinn (New York: Barnes and Noble, 1998).

The Unknown World of the Mobile Home, with Michelle J. Rhodes and John T. Morgan (Baltimore: The Johns Hopkins University Press, in association with the Center for American Places, 2002).

The Changing Scale of American Agriculture (Charlottesville: University of Virginia Press, 2003).

Landscapes of Minnesota—A Geography, with Susy S. Ziegler (St. Paul: Minnesota Historical Society Press, 2008).

My Kind of County: Door County, Wisconsin (Chicago: The Center for American Places at Columbia College Chicago, 2008).

ABOUT THE BOOK:

My Kind of County: Door County, Wisconsin was brought to publication in an edition of 2,500 hardcover copies, with the generous financial assistance of the Elizabeth Firestone Graham Foundation, Ray Graham, President, and the Friends of the Center for American Places, for which the publisher is most grateful. The text was set in Akzidenz Grotesk, and the paper is Chinese Goldeast, 128 gsm weight. The book was printed and bound in China. For more information about the Center for American Places at Columbia College Chicago, please see page 164.

FOR THE CENTER FOR AMERICAN PLACES AT COLUMBIA COLLEGE CHICAGO:

George F. Thompson, Founder and Director

Susan Arritt, Series Consulting Editor

Brandy Savarese, Associate Editorial Director

Jason Stauter, Operations and Marketing Manager

Amber K. Lautigar and A. Lenore Lautigar, Associate Editors and
 Publishing Liaisons

Purna Makaram, Manuscript Editor

Marcie McKinley, Design Assistant

David Skolkin, Book Designer and Art Director

Dave Keck, of Global Ink, Inc., Production Coordinator